SHARDS OF AMERICA

PHIL BERGERSON

SHARDS OF AMERICA

INTRODUCTION BY DAVID HARRIS

THE QUANTUCK LANE PRESS

NEW YORK

One of the things that I've always admired about the United States

is that this is a country which declares its independence by stating that its citizens

have the right to the pursuit of happiness. There isn't another country in the world

which declared independence on the basis that people should be happy.

SALMAN RUSHDIE, 2002

"We Meet by Accident"

Reading *Shards of America*

A back-lit sign, WE MEET BY ACCIDENT, appears toward the end of Phil Bergerson's *Shards of America.* This oddly affecting phrase might well have been directed to the prospective reader who has chanced upon this book. Having picked it up and flipped through it, perhaps lingering over several of the images, such a reader might wonder what it all means. This is clearly a collection of thematically and geographically related photographs, but for what purpose—celebratory, descriptive, or satirical—have they been brought together? Should the images be considered separately, independent of one another, or do they form a single entity, one in which all the photographs are subsumed and ordered into a larger imaginative whole? Is this a book of photographs or a book in photographs?

Photographers have frequently published selections of their work, using the form of the book as an ideal means of presenting and preserving it, but *Shards of America* draws upon a particular lineage within this larger tradition, one that, at least in North America, can be traced back to Walker Evans's 1938 publication *American Photographs.* This seminal volume established a new kind of photographic book. In it, Evans addressed American culture as a whole and conveyed his interpretation solely through the arrangement of the photographs.

Evans felt that America could best be understood through an examination of its material culture. In his view, the values of a society are embedded in the forms typically created by it, manifested, in this case, by its indigenous and commercial architecture, its industrialized urban landscape, and, among other aspects, its vernacular artifacts and manufactured products. Photography could describe these forms while simultaneously uncovering and revealing an underlying structure of values. Evans deliberately straddled the distinct but related roles of reporter and cultural commentator, producing carefully observed images that were supported by strongly held convictions. The resulting book consists of two extended sequences of rigorously selected photographs, presented without captions, and followed by an afterword by Lincoln Kirstein, which provided an historical context for the work. Evans intended *American Photographs* to be "read" as if, in some senses, the individual photographs were the equivalent of words, sentences, and even entire paragraphs, and the two sequences constituted discrete chapters of the book. The burden of interpretation lay with the photographs, both individually and as sequences, and with readers' willingness to intuit meaning from a sustained reading of the images.

Walker Evans's publication has cast a long shadow across American photography, and its influence can be

seen in such later books as Robert Frank's *The Americans* (1959), Joel Sternfeld's *American Prospects* (1987), Lee Friedlander's *Letters from the People* (1993), and, among more recent compilations, Florian Böhm, Luca Pizzaroni, and Wolfgang Scheppe's *Endcommercial® Reading The City* (2002). In spite of differing approaches and emphases, each of these publications can be seen as furnishing a contemporary report on American culture, a periodic update of Evans's *American Photographs. Shards of America* takes its place along this trajectory.

In the early 1990s, Canadian photographer Phil Bergerson began exploring and photographing the North American urban landscape. Instinctively, he gravitated to the neglected corners of towns and small cities where he found the material that would comprise his own mapping of this enormous territory. By 1995 the project had centered on the United States alone and increasingly, but not exclusively, focused on two aspects of the urban fabric: shop window displays and urban signs. Such a decision could have been limiting, engendering a standardized treatment of the subject but in Bergerson's case it had the opposite effect. This concentration provided him with a point of entry, one suited to the perspective of an outsider.

In these often overlooked and seemingly inconsequential features of city life lay enormously rich and diverse visual material. Businesses, religious sects, and community groups variously use display techniques and storefronts to announce their presence, offer their services, and pitch their messages, while commercial signs, graffiti, posters, and public notices indiscriminately blanket the surfaces of buildings and public spaces. Displays and signs form an insistent presence in cities, structuring our perception of this environment and, to a large extent,

mediating our relationship to it. They furnish information, offer advice, solicit opinions, champion community values, provide a forum for public outcry, and act as a goad to rampant consumerism. In this dense layering of voices, display creates the visual cacophony found in urban spaces, where disconnected messages and disembodied utterances jostle with one another for attention. Although such displays and signage serve similar functions throughout North America, they also reveal, upon closer study, regional variations and differences in scale and intended audiences. In their ordinariness, they represent what is ubiquitous across an entire continent.

For this project, Bergerson used a medium-format camera and color film, producing square images, rich in compelling detail. He frequently worked at close range to his subject, in turn inviting us as viewers to immerse ourselves in an examination of the objects displayed and to begin imagining the lives of the people associated with them. Paintings and movie posters, dime-store novels and daily newspapers, figurines and mannequins, decals and stenciled graffiti, and children's letters and drawings are laid out, almost as anthropological artifacts, for our perusal. Such photographs constitute poignant still lifes, memorializing the anonymous and ephemeral displays and the collages of slogans and fervent messages.

In other views, Bergerson moved slightly farther away to reveal how the window displays and signs participate in the larger life of the street. In some instances, a sense of place is created by the surface of plate-glass windows, where the contents of a storefront mingle with the buildings directly opposite, and occasionally include the shadowy presence of the photographer at work with his camera on its tripod. Elsewhere, slivers of the sidewalk

and facades of adjacent stores or partially glimpsed rooflines and the distant sky serve to ground the buildings in their gritty urban environments. Interspersed with these detailed images are a few more distant views: an intersection in a small town; signs scattered along regional highways. While all of the images can be understood as describing, in a generic sense, the United States at any point at the end of the twentieth century, ten photographs record the shock waves unleashed by the events of September 11, 2001. These images provide the book with its historical specificity as well as an emotional urgency, but they share common themes and values with the book's other images.

Most of the photography was completed by the spring of 2002, at which time Bergerson began the lengthy process of selecting images and editing them for this book, eventually incorporating more recent photographs to complete the sequence. With the exception of the first introductory image, which appears alone on the right-hand page, the book consists of an unbroken sequence of sixty paired images, which, as double-page spreads, establish the book's conceptual framework, its structure, rhythm, and authorial voice.

The governing principle of the entire project is that of juxtaposition—the deliberate placement of two or more objects in close proximity for purposes of comparison. This process can be seen operating on four distinct levels, each contributing its own layer to the interpretation of the subject and, cumulatively, to the formation of the book. To begin with, there are the original displays assembled by the shopkeepers, preachers, and ordinary citizens, and the unruly configurations of signs, posters, and graffiti. These initial arrangements of objects and clusters of texts function as evidence, raw material in a

sociological sense, of the complex process of communicating information and beliefs within a society. With the passage of time and the loss of local context, part of the original intention behind these groupings slips away and, even now, can no longer be fully recovered and deciphered.

At a second level are the aesthetic decisions that Bergerson made in framing and composing his photographs, decisions concerning what should be included and what could be left out. Standing closer or farther away, angling his camera more squarely or obliquely, or returning on another day would have resulted in very different images. Here, the sense of detached observation begins imperceptibly to elide with social comment. Thirdly, there are the juxtapositions created in the preliminary editing stage of the book, when two photographs are placed side by side in a double-page spread. Images taken years apart and in entirely different parts of the country have been brought together and harnessed as a pair, in which considerations of color harmonies and thematic relationships assume greater importance than geographical or temporal proximity.

Finally, there are the intricate and complex decisions governing the book's overall structure, whereby the individual spreads have been ordered into a coherent sequence. Only through the precise orchestration and rhythm of succeeding pairs could something as complex as a nation's culture be evoked and distilled. At this final level, the separate functions of documentation and commentary have merged completely.

Each pair of photographs is keyed to a single color or range of colors. Primarily, subtle tonal variations—warm reds, dusty browns, quiet beiges, cool pinks, or sooty whites—will permeate both images, although occasionally

one strident color—yellow, blue, green, and crimson—will dominate the page spreads. These combinations animate, subdue, or temper the mood implicit in the images. Color invites readers' eyes to glide effortlessly across the two images and to consider them as a single composite whole, and, in proceeding through the volume, to discover relationships between the preceding and succeeding pages. While color assumes this mediating function, thematic considerations play a quite different role. Pairs of images provided Bergerson with a flexible tool and the critical means to organize his impressions and offer his vision of American culture.

Traditional family values, relationships between men and women, religious and community standards, patriotism, consumerism, censorship, a simmering violence, and a nostalgia for a simpler past coupled with a desire for a less complicated present are some of the themes treated in the individual spreads, although these themes are approached obliquely. Bergerson is as concerned as Evans had been in *American Photographs* with revealing how a system of values nourishes and links what might initially appear as distinct and unrelated spheres of activity. However, unlike Evans, Bergerson uses the device of paired images to do this.

In *Shards of America,* the societal themes are presented neither singly nor in isolation but as overlapping visual conjunctions. Photographs treating aspects of religious and spiritual values, to take one instance, are variously combined throughout the book not only with images espousing conservative family values, as one would expect, but also with ones saturated by commerce and patriotism or tinged with nostalgia. While an individual image may contain dense accretions of graphic imagery and vernacular typography when paired with another image, its meaning is qualified, subtly altered, or entirely transformed. In shifting our gaze between the two images, searching for connections (whether formal or iconographic), we invest hitherto unremarkable details with significance. A new meaning, as distinct from those derived from each photograph alone, emerges, hovering in an indeterminate space between the two images.

Each pair forms a self-contained unit, demanding and absorbing the reader's attention; each successive pairing presents another facet, an additional instance in a gradually accumulating description of a nation's physiognomy. From spread to spread, the book's internal development is controlled by a subtle progression of colors, by echoes of thematic imagery, and by lateral shifts in subject matter. Pairs of images harbor mysteries, register disturbances, and elicit questions; they mirror society's disjunctions—its conflicting values and unresolved aspirations—and expose its latent preoccupations, such as the confluence of violence, eroticism, and consumerism. It is through the repetition, variation, and cumulative effect of the pairings that the various aspects of a culture are shown to be interconnected and how, in their particular combinations and transformations, they characterize and epitomize this society as distinct from others. Throughout, Bergerson's tone remains quietly ironic but empathetic, at times playful, at other times elegiac, finding a mixture of wonder, astonishment, confusion, and a lingering fascination in what he has discovered and documented.

A *shard* is a fragment of broken pottery. It is sometimes all that remains of past civilizations, and archaeologists may spend months in the meticulous though only partial reconstruction of the original objects, whose

purposes and functions may no longer be entirely understood. *Shards of America* suggests that Bergerson, in addition to his roles as recorder and commentator, has also assumed the persona of the archaeologist. To inhabit this last role, he had to distance himself psychologically from the present and imagine how these modest displays and groups of signs might appear to viewers in a hundred or more years' time. How would they be read and how would such a reading differ from our own? In this guise, the photographer's role lay in sifting through, unearthing, and culling these overlooked remnants of a culture, and in assembling them into meaningful configurations. In this sense, the photographs can be thought of as shards, and the clusters and strings of paired images understood as delicate but incomplete vessels, which have been carefully gathered and preserved in this book.

—David Harris, 2004

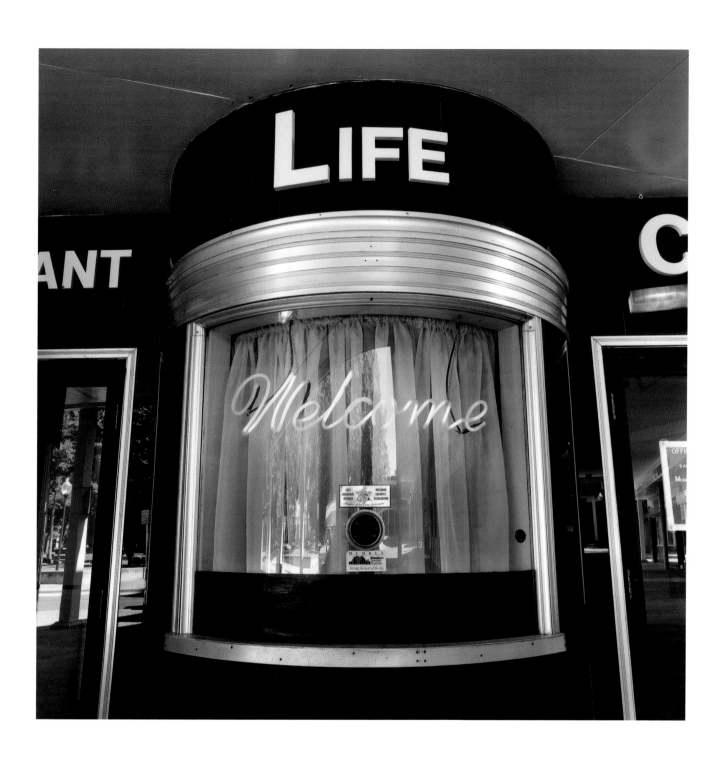

Springfield, Missouri, 1998

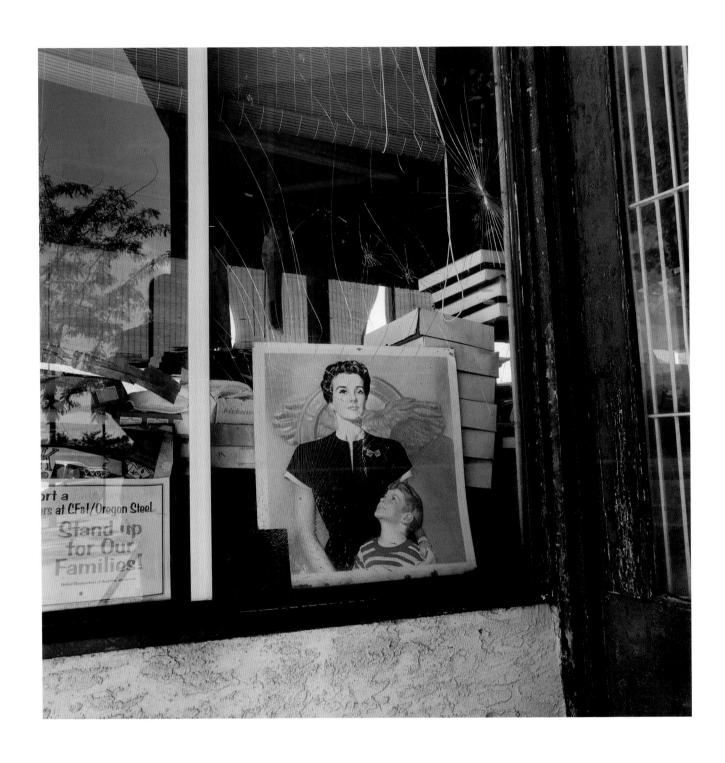

Pueblo, Colorado, 1999

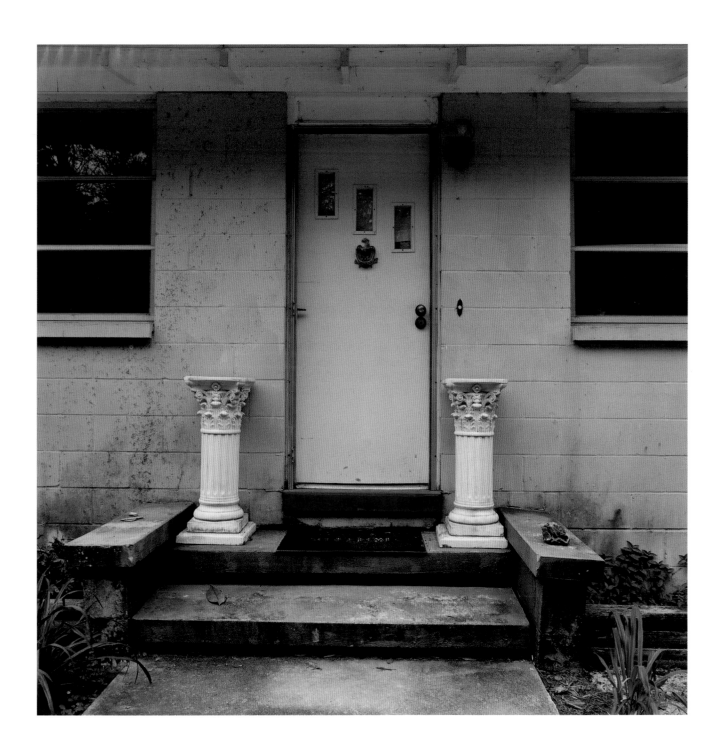

Micanopy, Florida, 1998

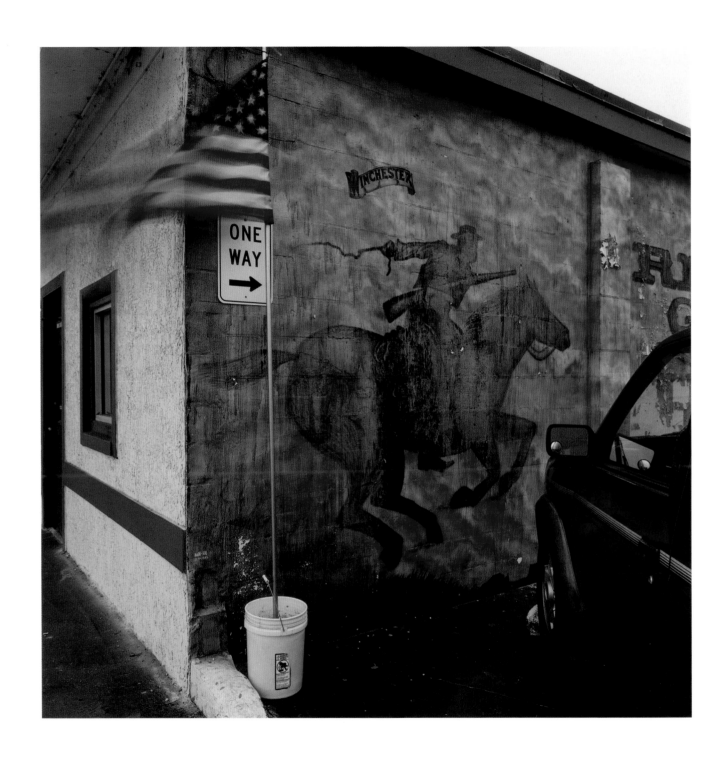

Orlando, Florida, 2001

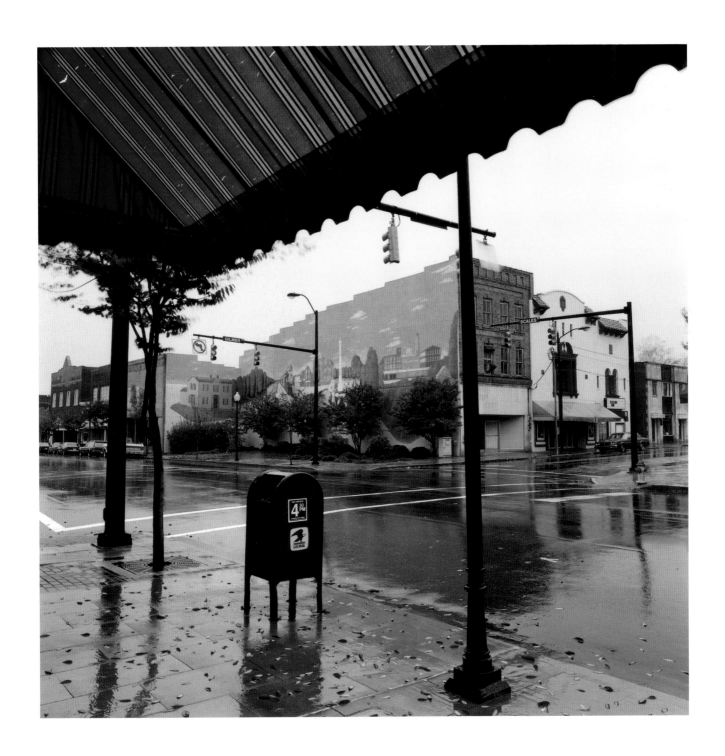

Reidsville, North Carolina, 1996

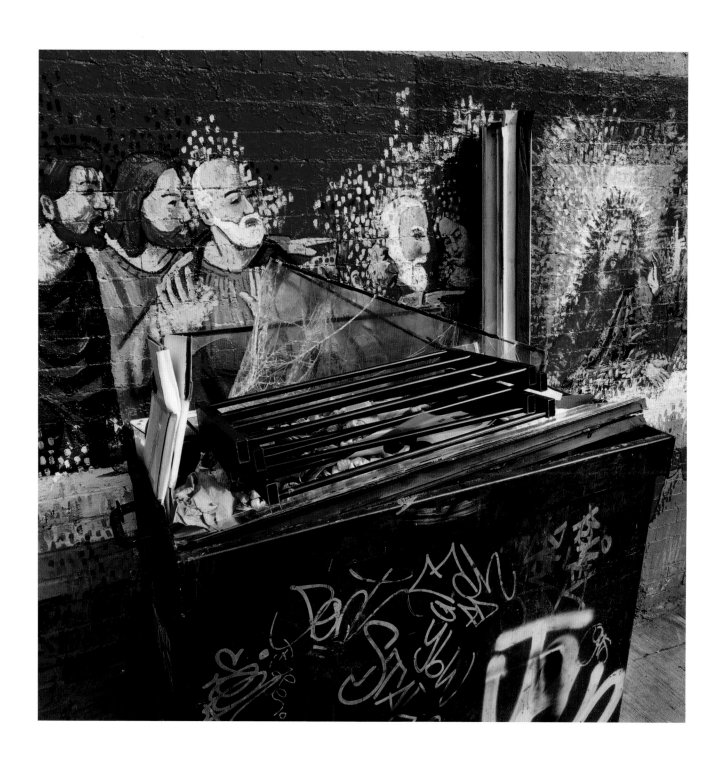

New York (Harlem), New York, October 2001

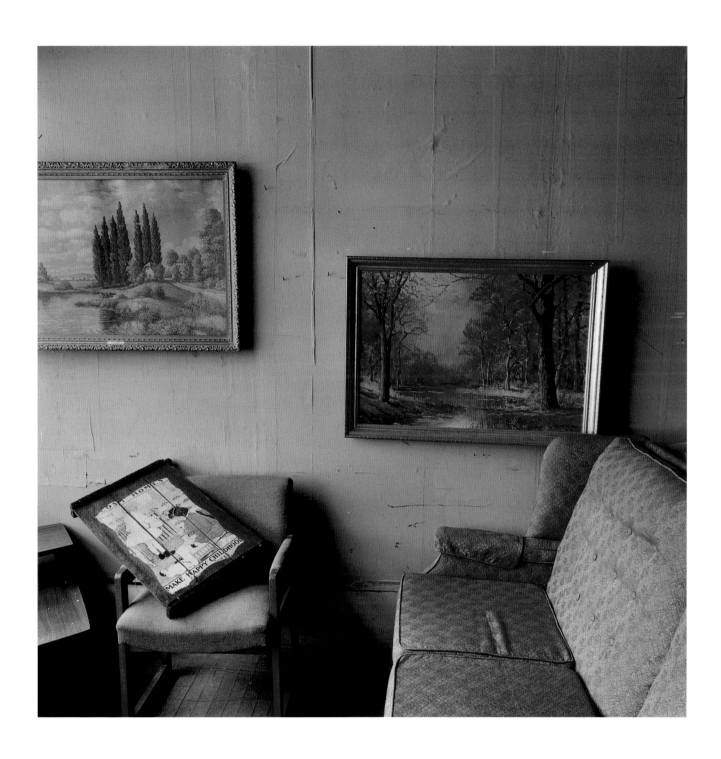

Richmond, Indiana, 1998

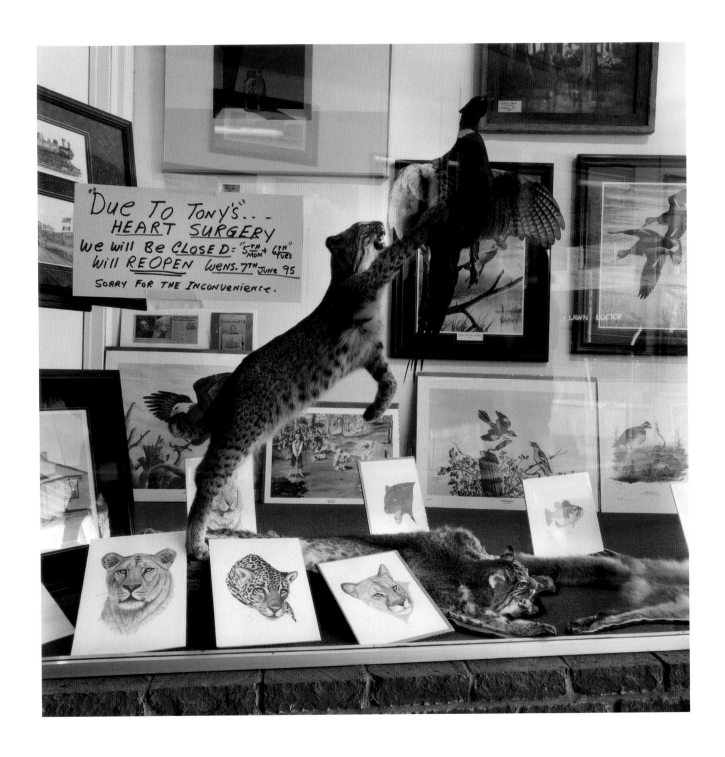

Tennessee, 1996

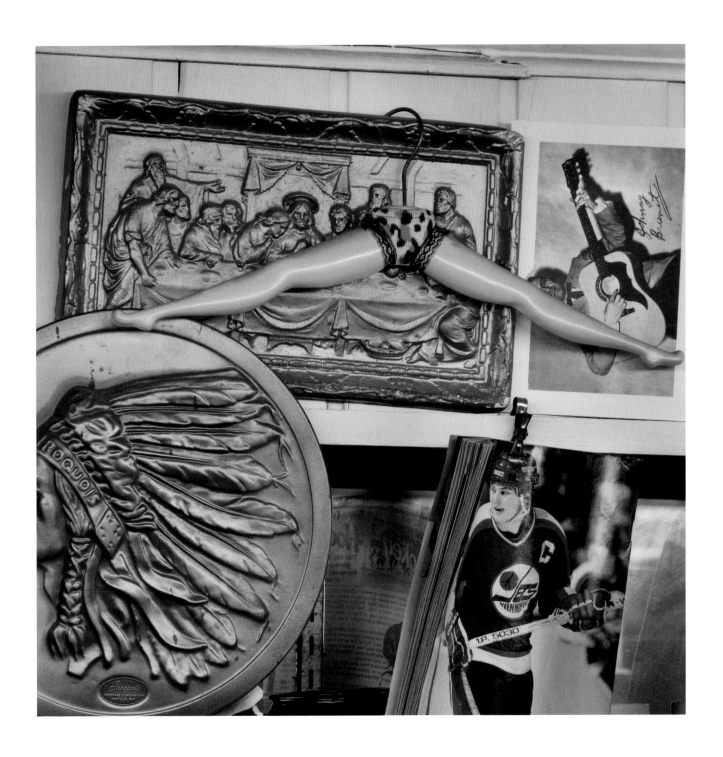

Cornwall, 1991

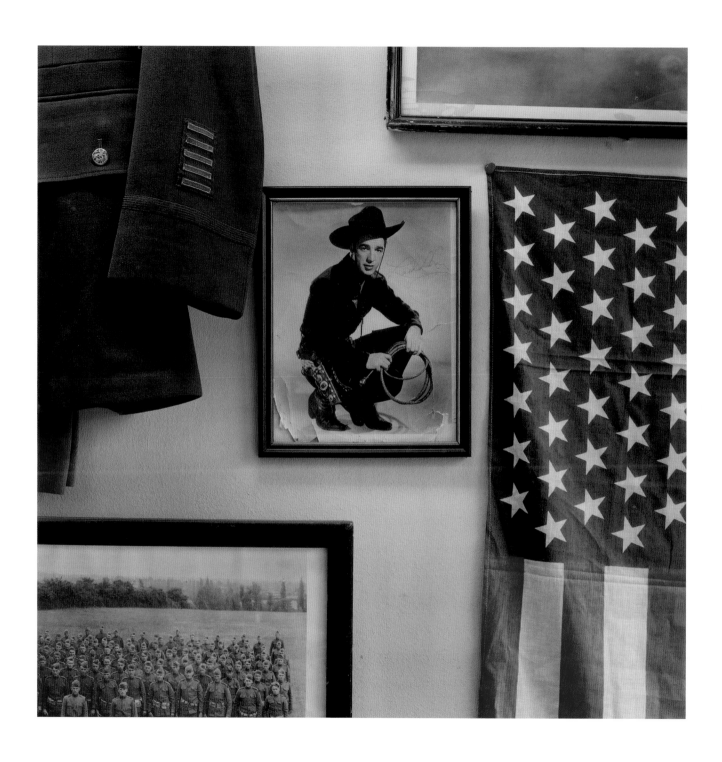

Alexandria, Louisiana, 1997

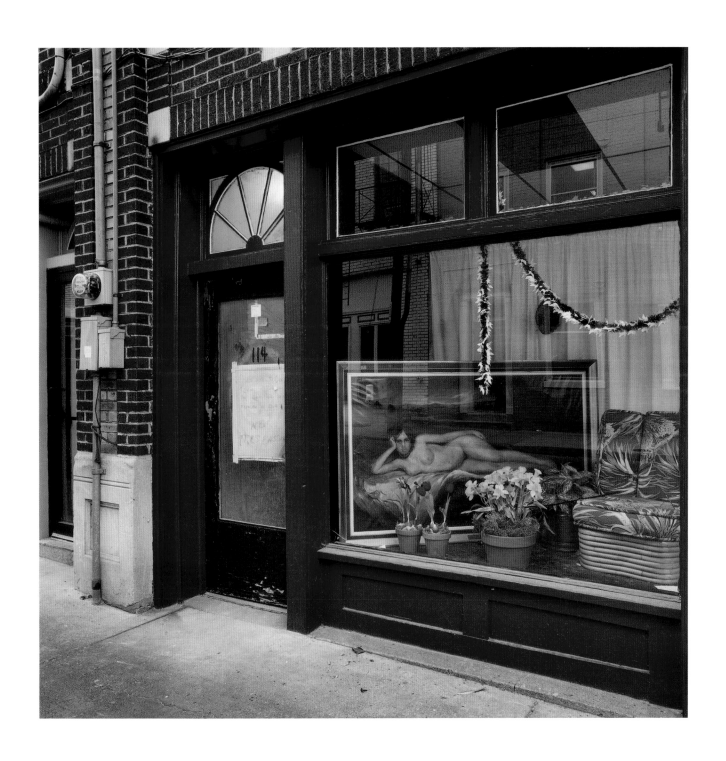

Lexington, Kentucky, 1997

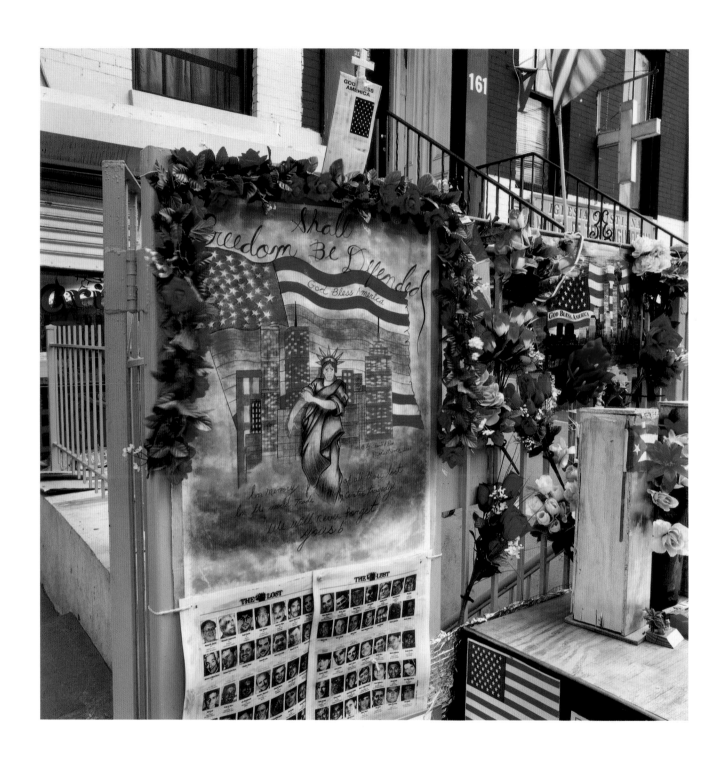

New York (Harlem), New York, October 2001

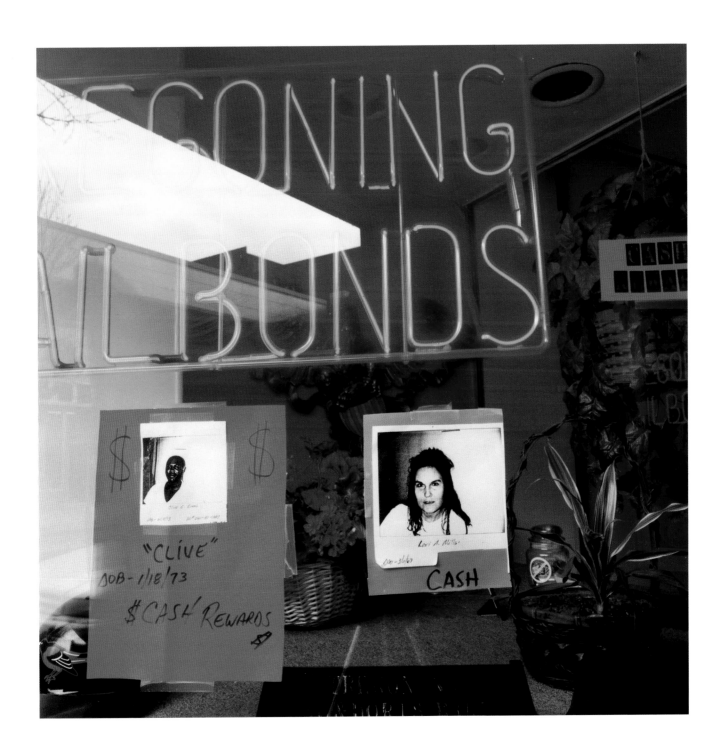

Hagerstown, Maryland, 1997

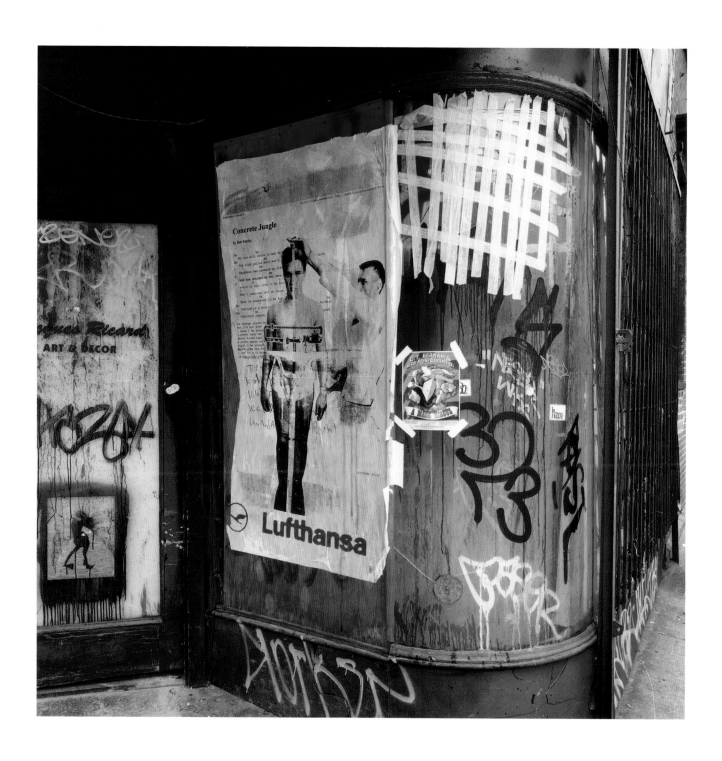

New York, New York, June 2001

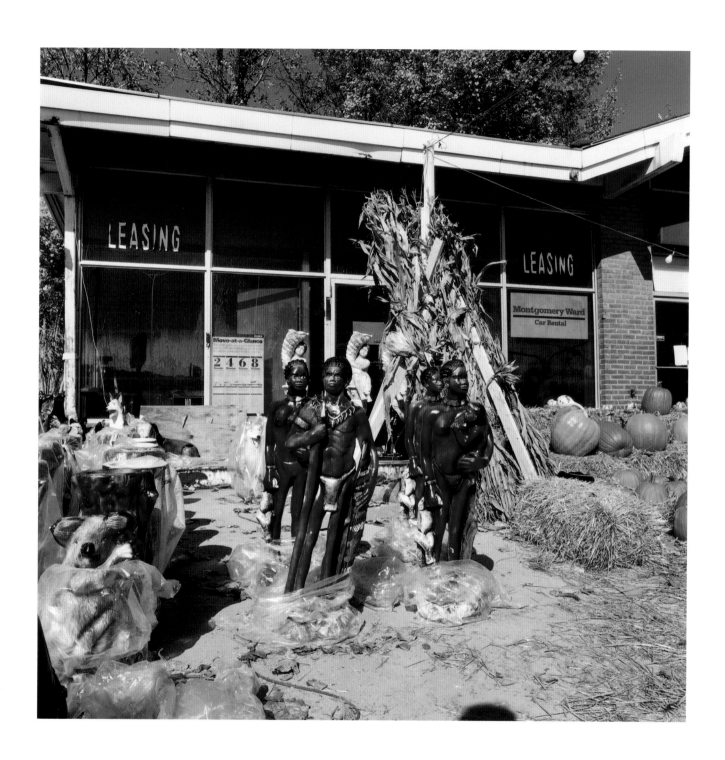

Washington, D.C., 1997

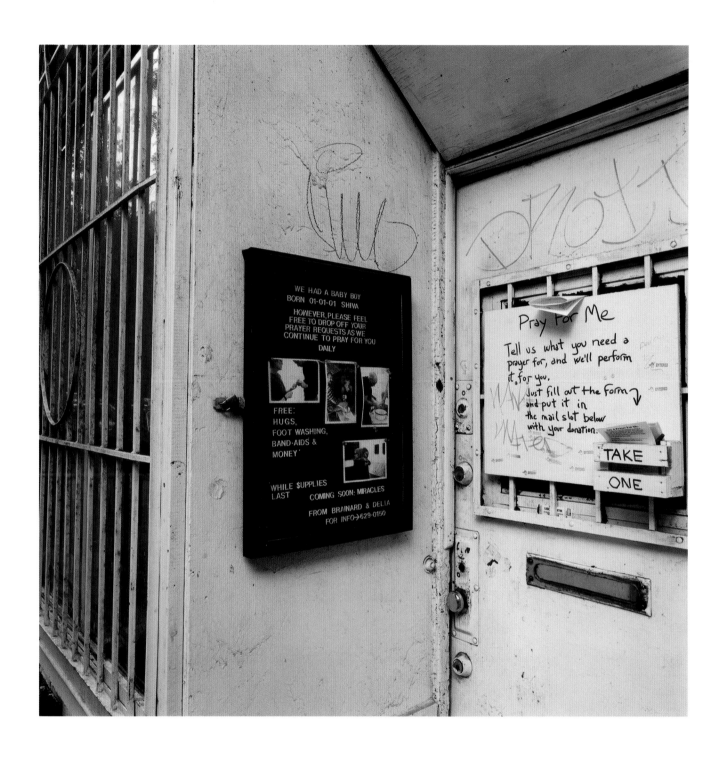

New York, New York, June 2001

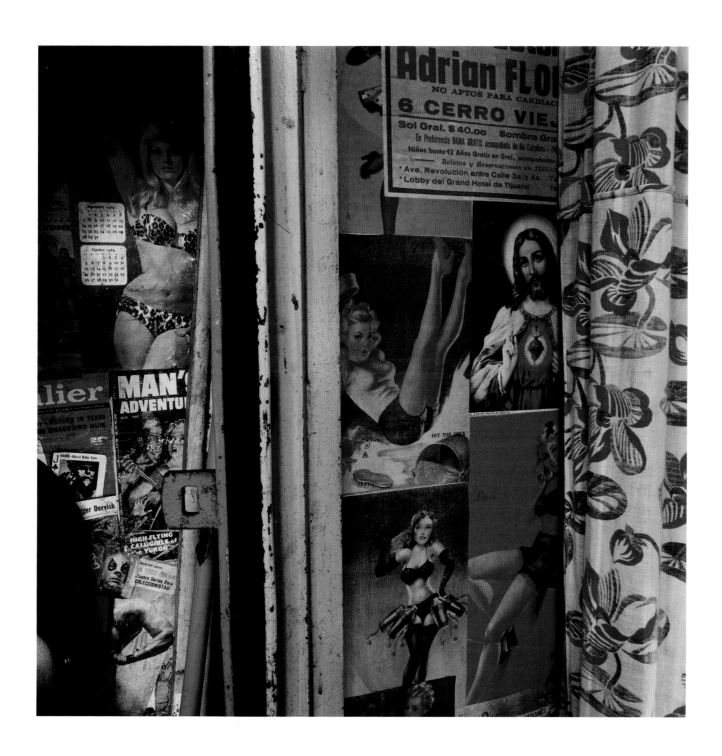

New York, New York, June 2001

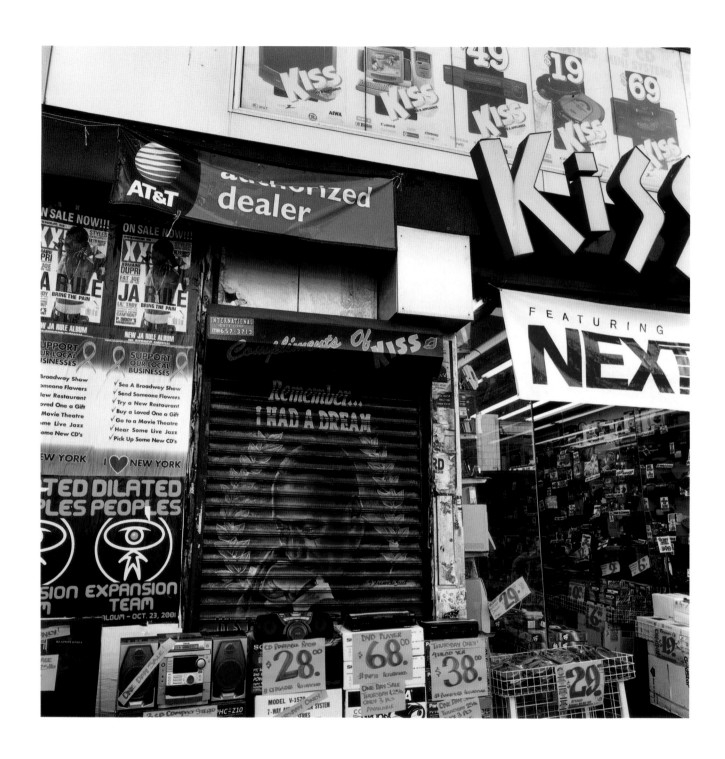

New York, New York, October 2001

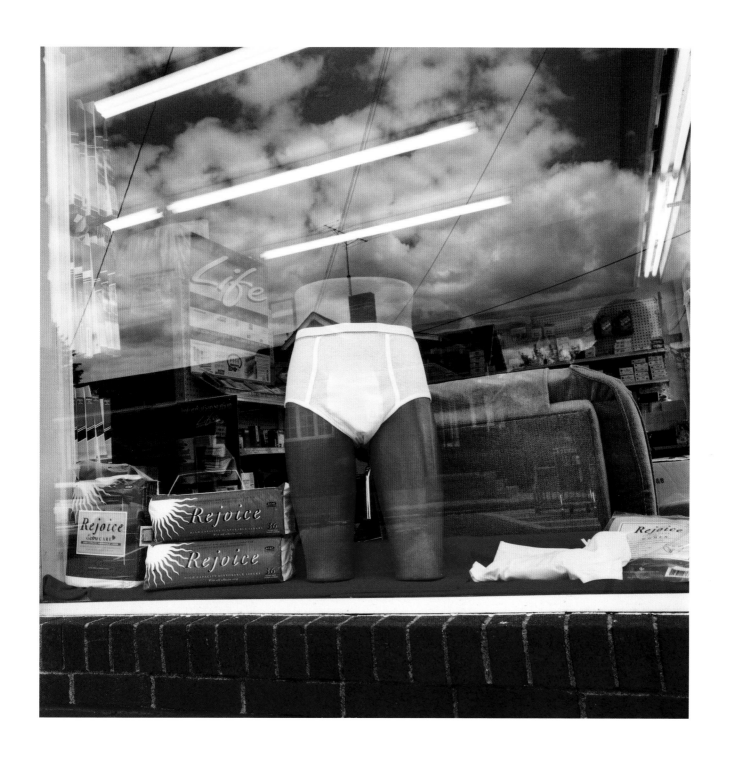

Mars, Pennsylvania, 1996

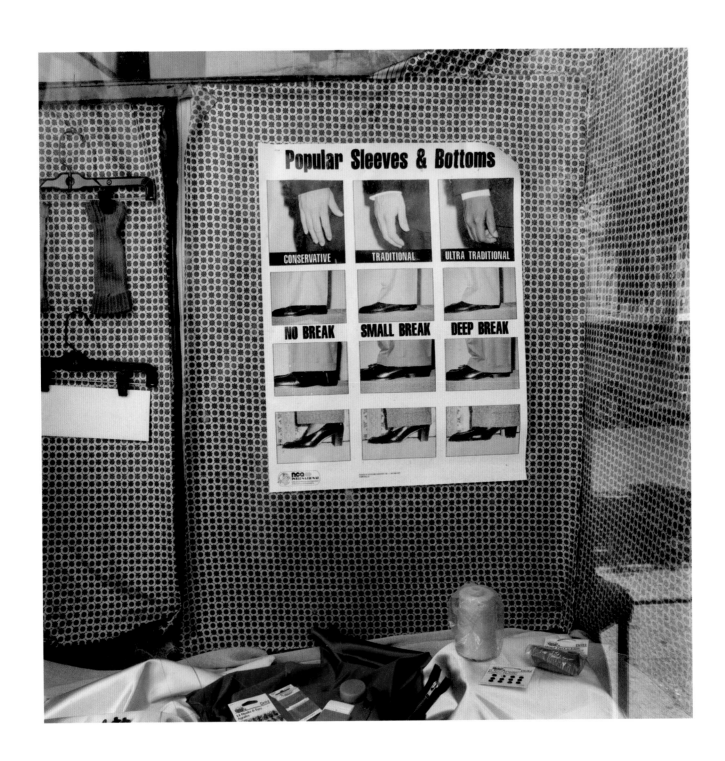

New York, New York, June 2001

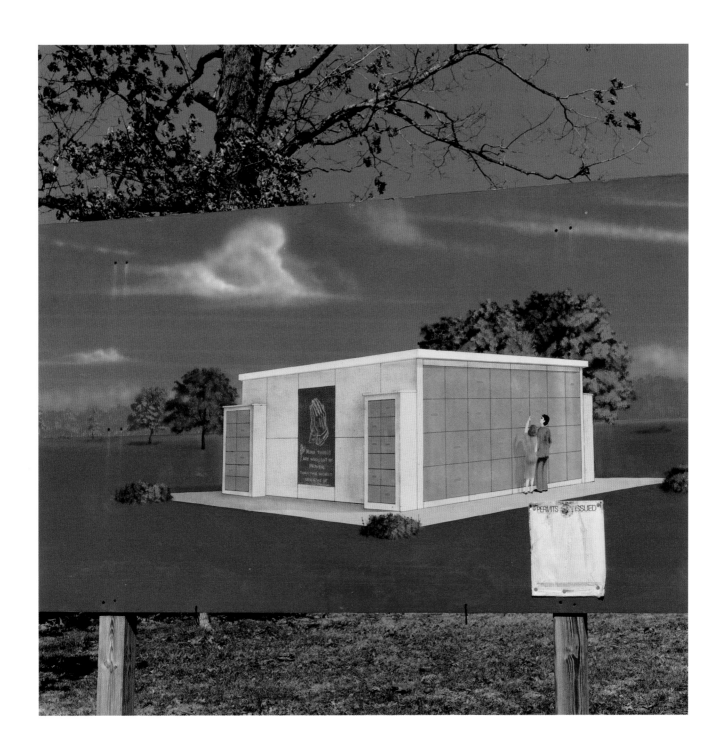

Chancellor, Virginia, 1997

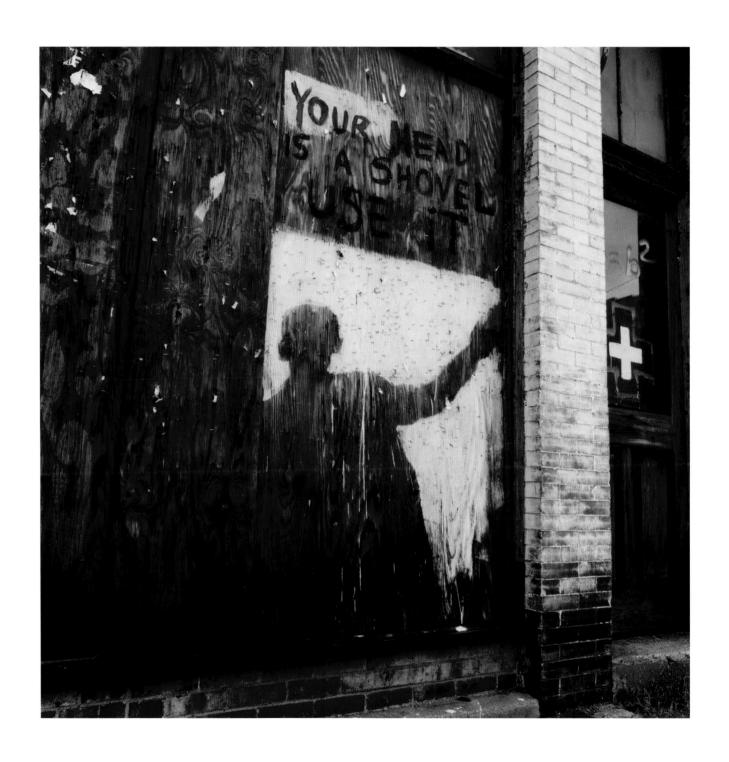

Norfolk, Virginia, 1996

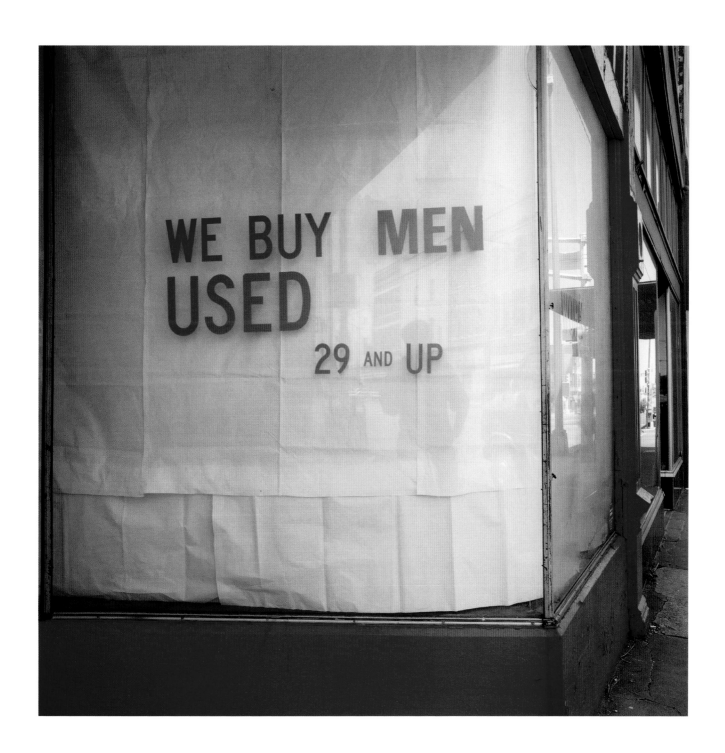

Springfield, Missouri, 1998

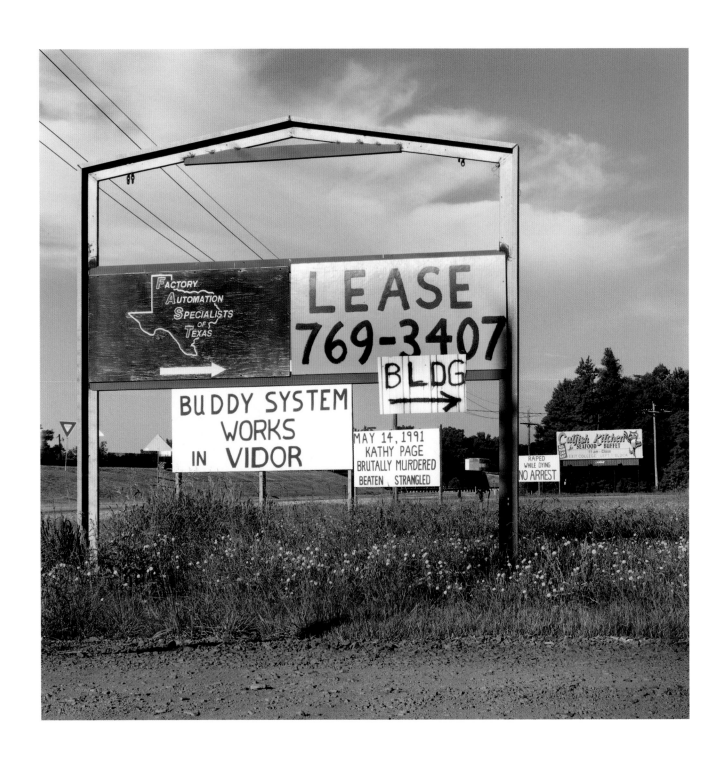

Rose City, Texas, 1998

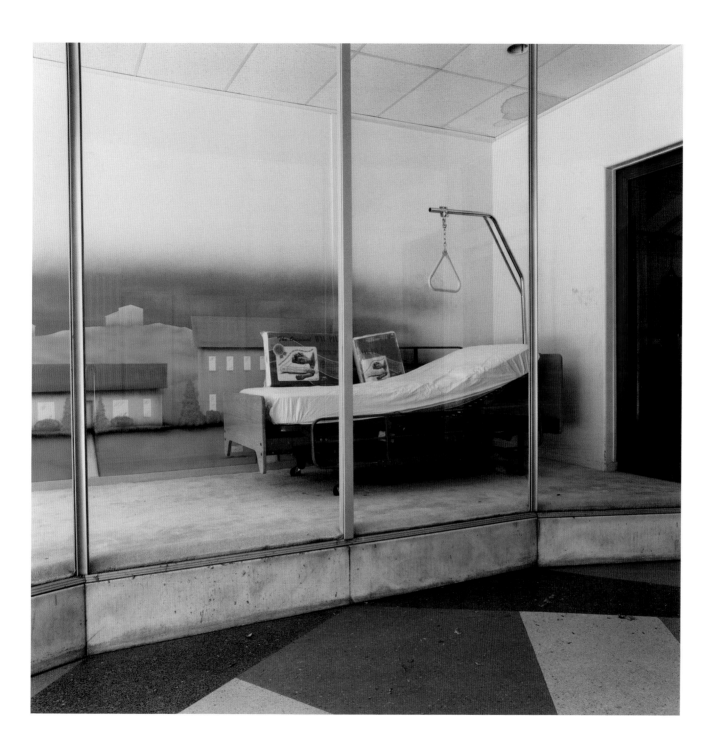

Pueblo, Colorado, 1999

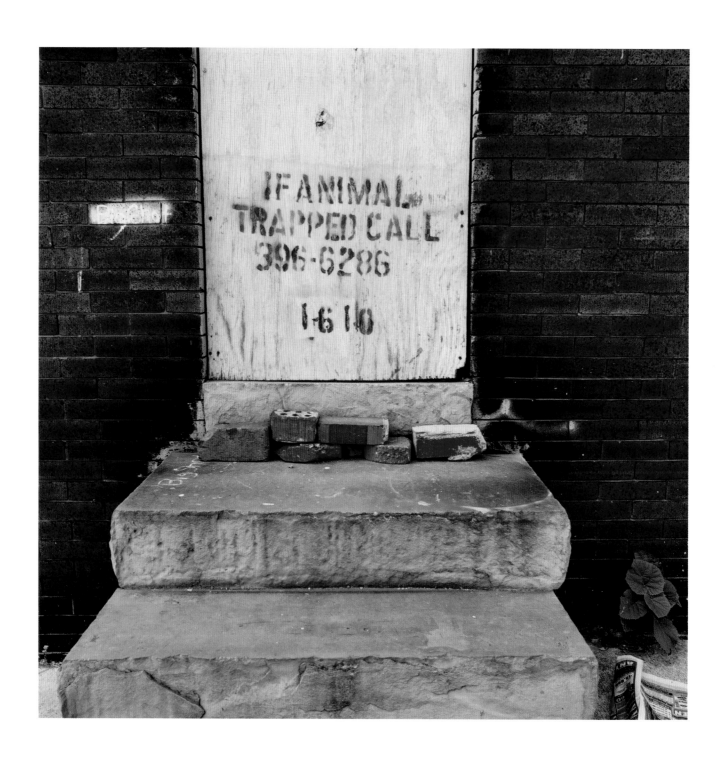

Baltimore, Maryland, 2002

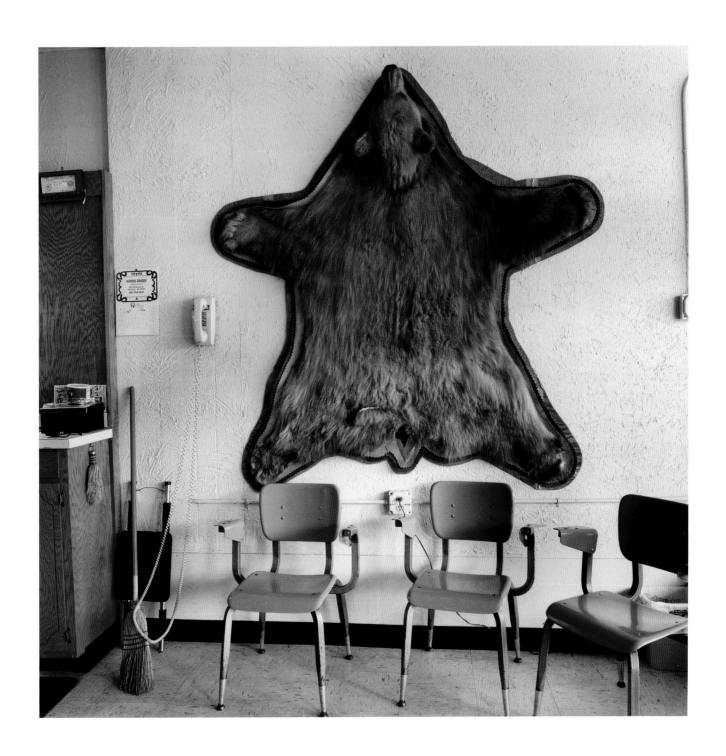

Harrison, Arkansas, 1998

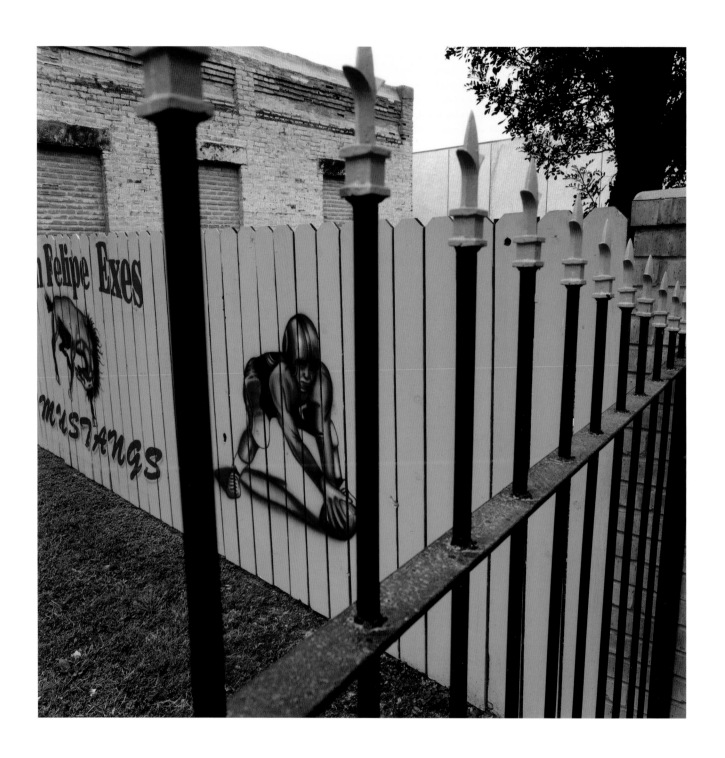

Del Rio, Texas, 1999

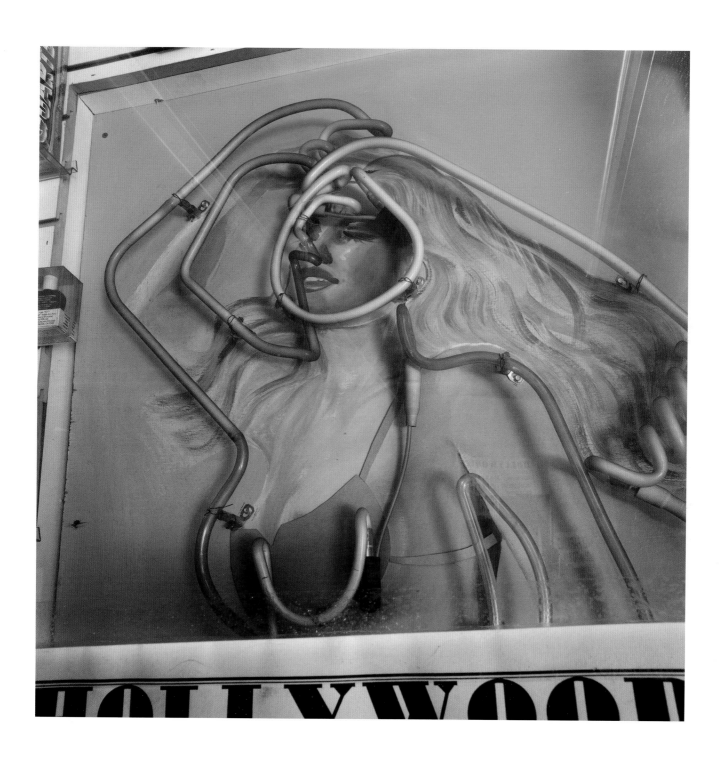

Los Angeles, California, 2000

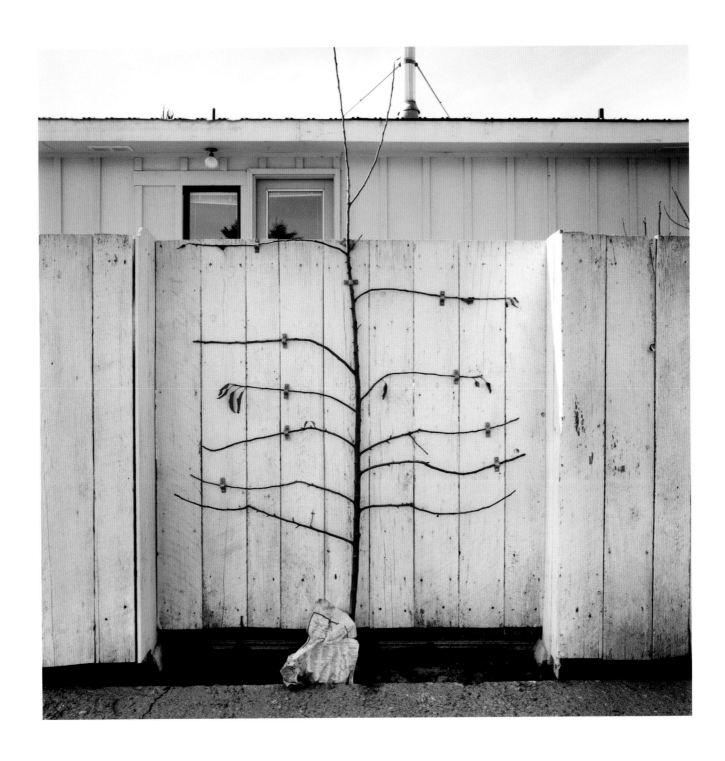

Cle Elum, Washington, 1993

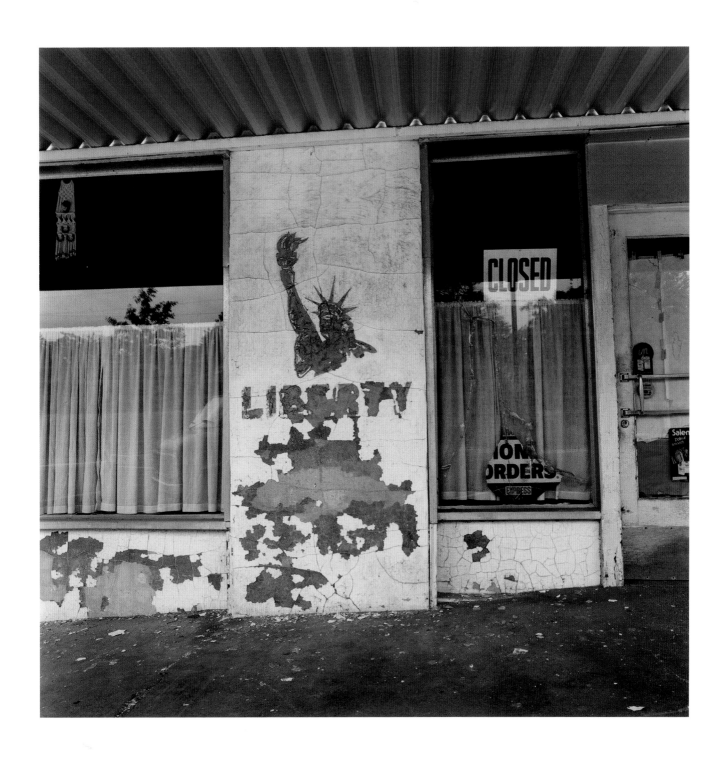

Winona, Mississippi, 1998

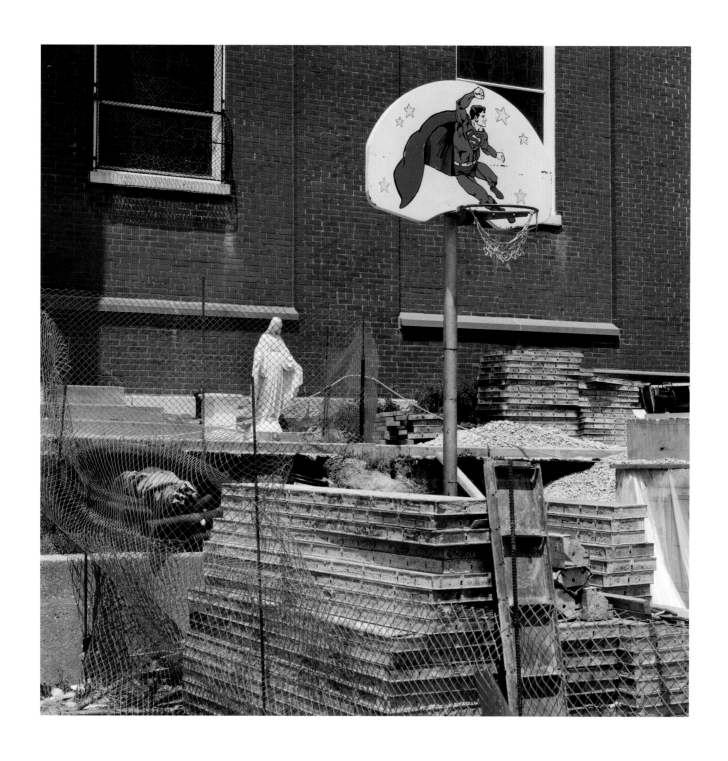

St. Charles, Missouri, 1998

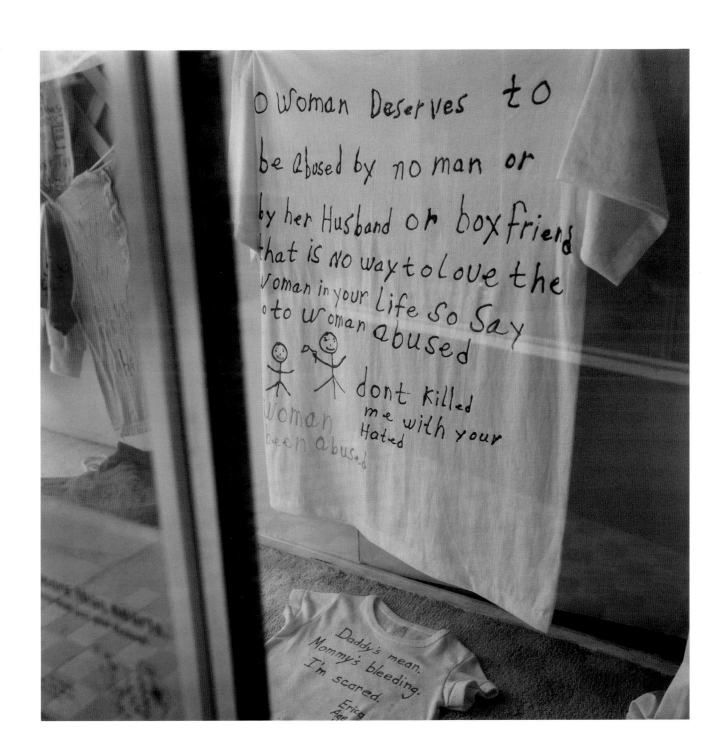

Wichita, Texas, 1998

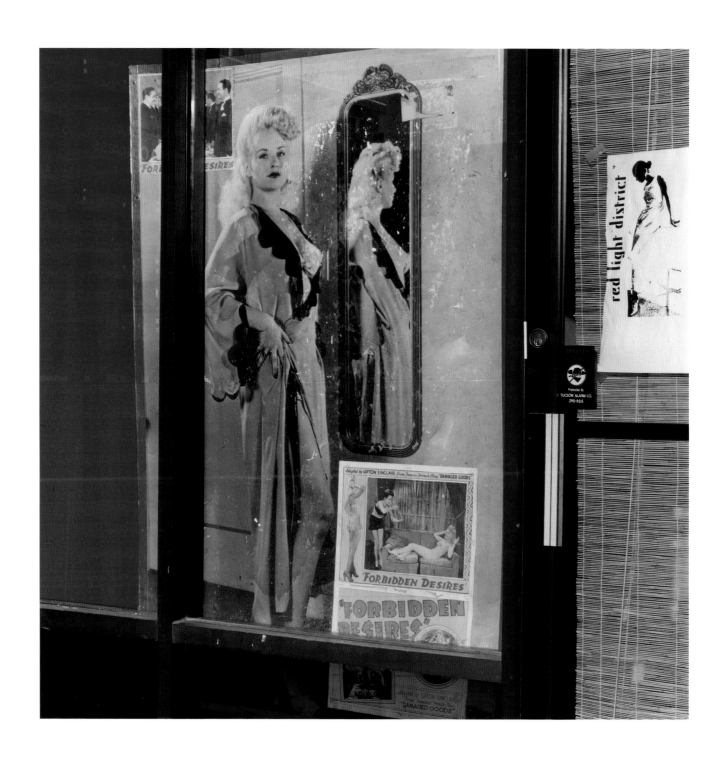

Tucson, Arizona, 1999

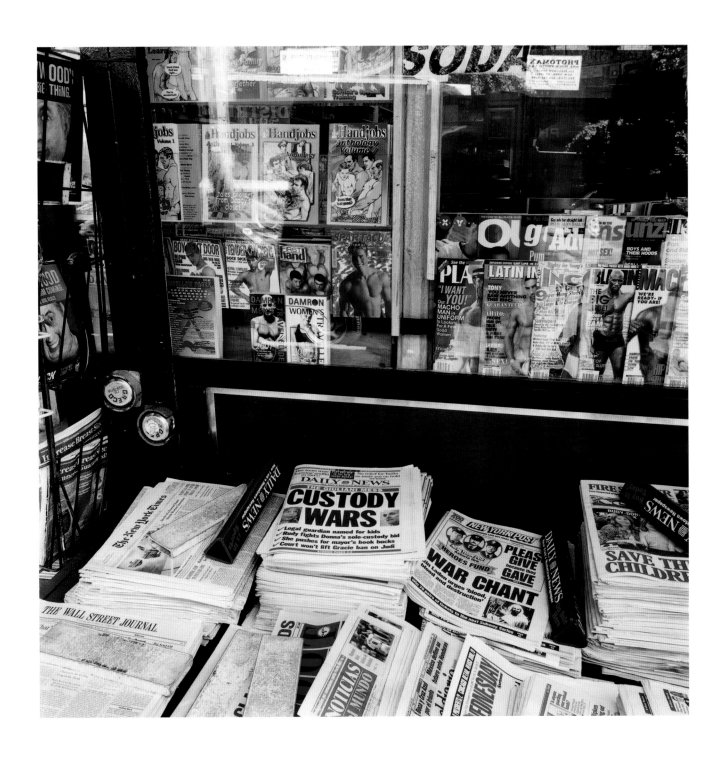

New York (Greenwich Village), New York, July 2001

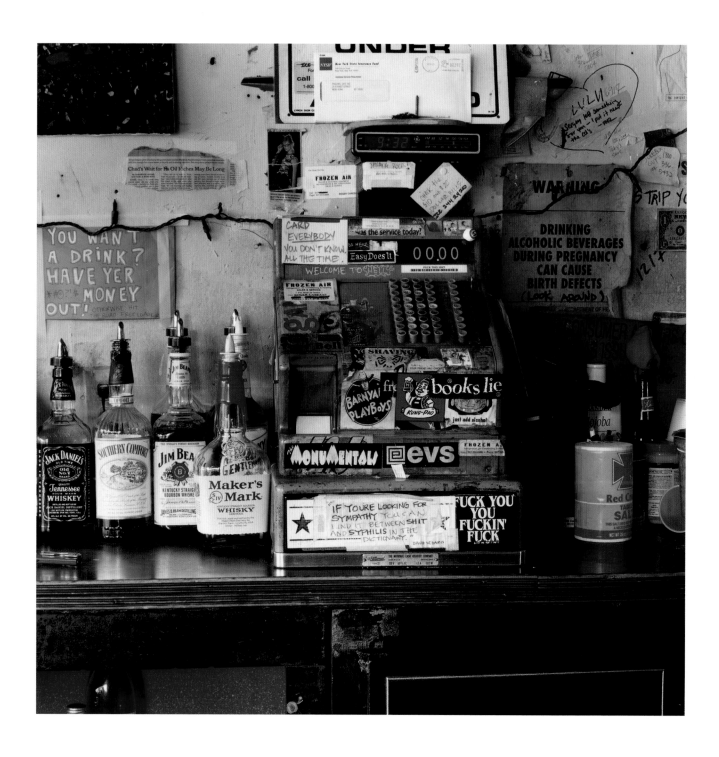

New York, New York, June 2001

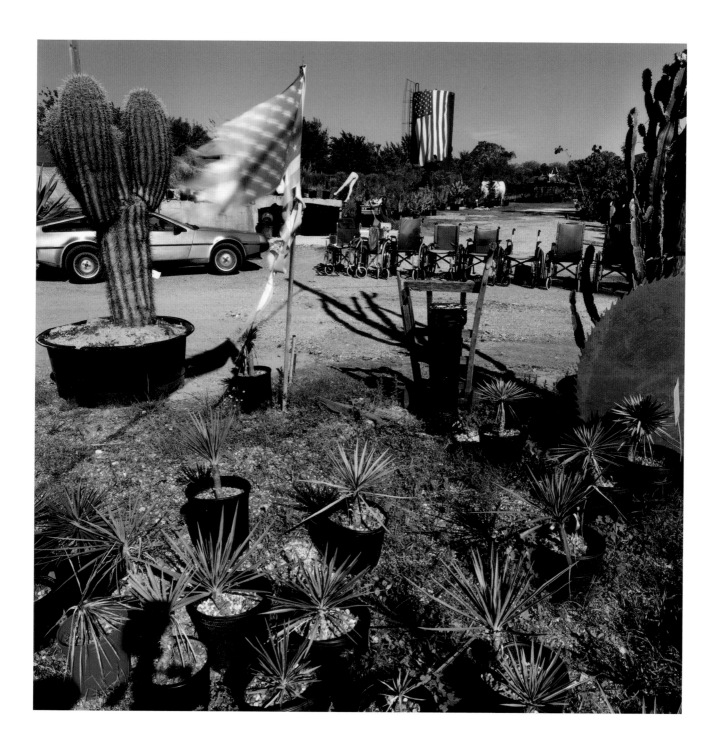

Houston, Texas, 1998

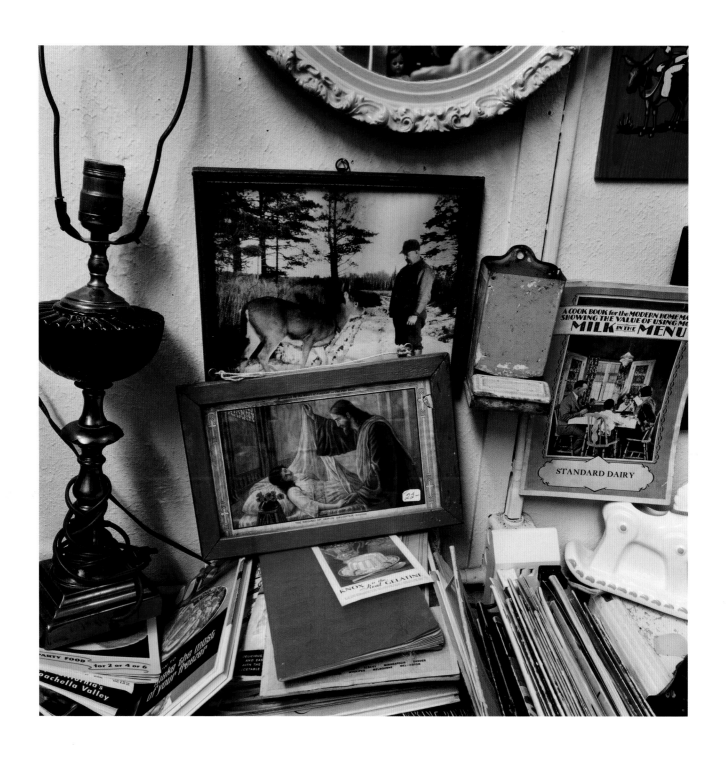

Truth or Consequences, New Mexico, 1998

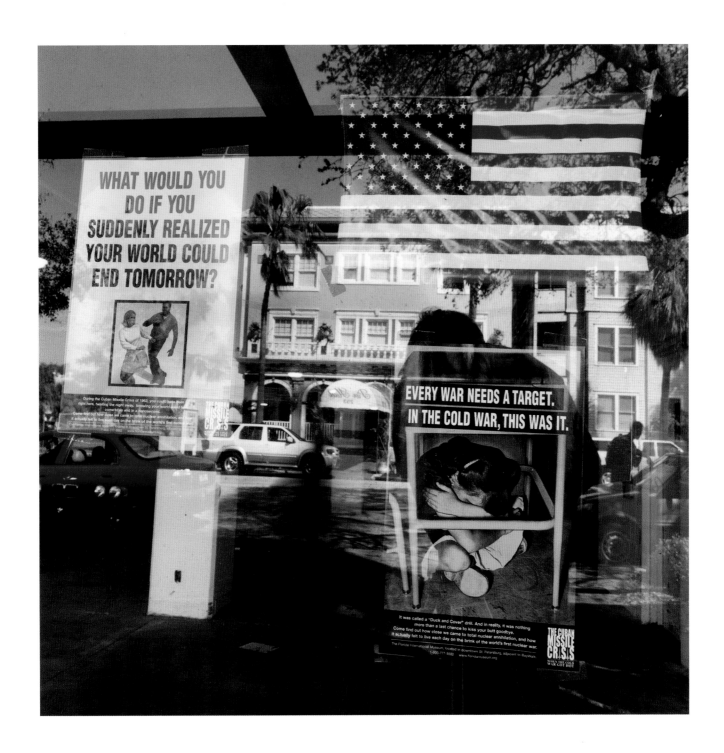

St. Petersburg, Florida, 2001

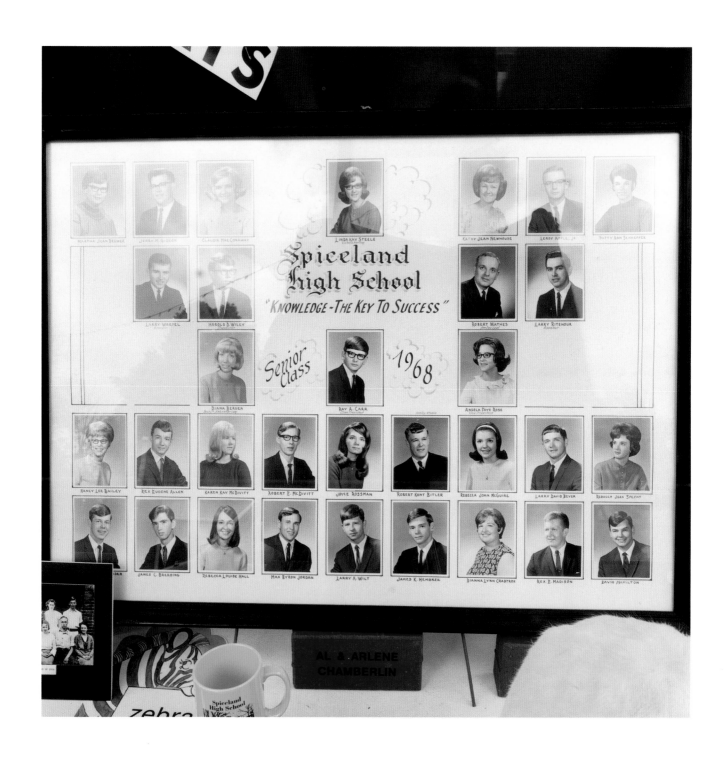

Spiceland, Indiana, 1998

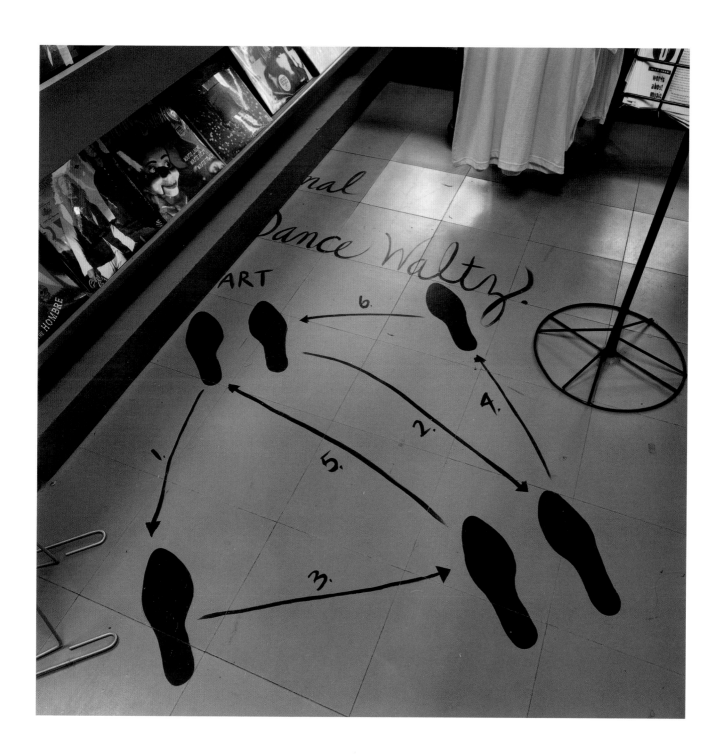

Champaign, Illinois, 1998

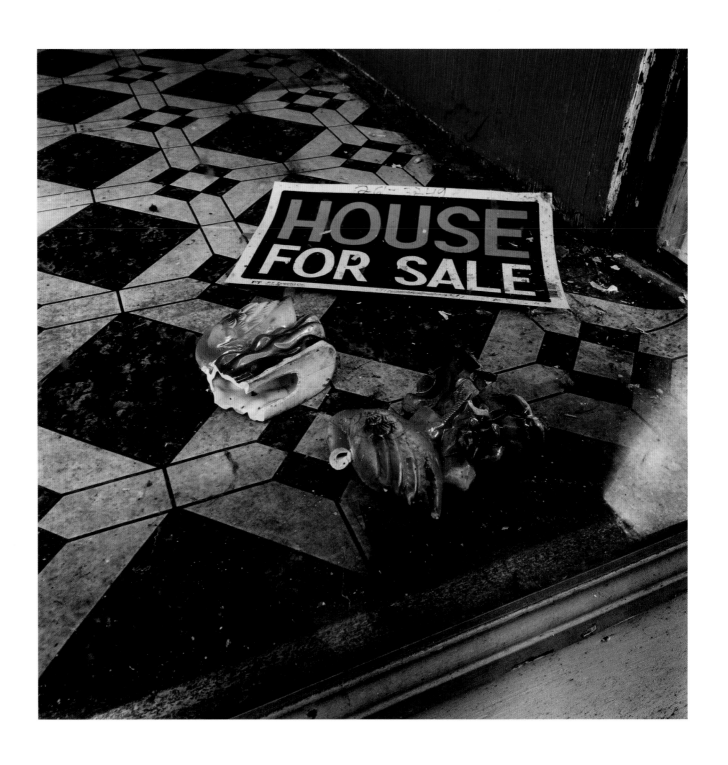

Baltimore, Maryland, 2003

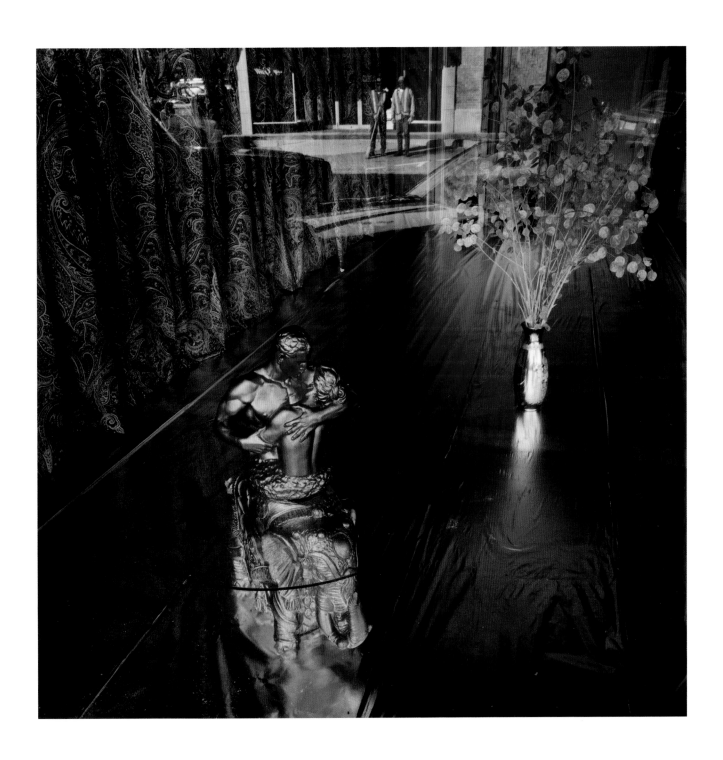

Florence, South Carolina, 1996

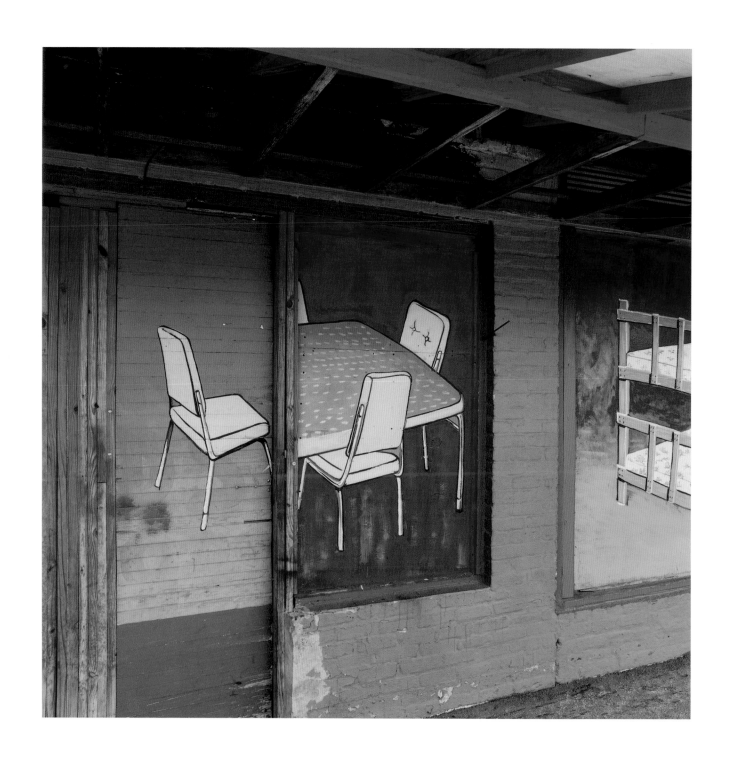

San Antonio, Texas, 1998

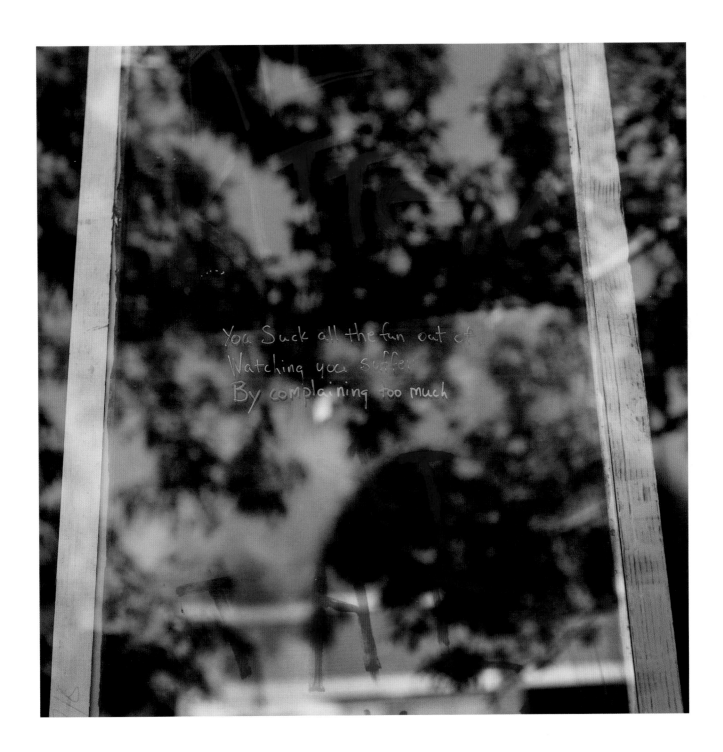

Denver, Colorado, 1999

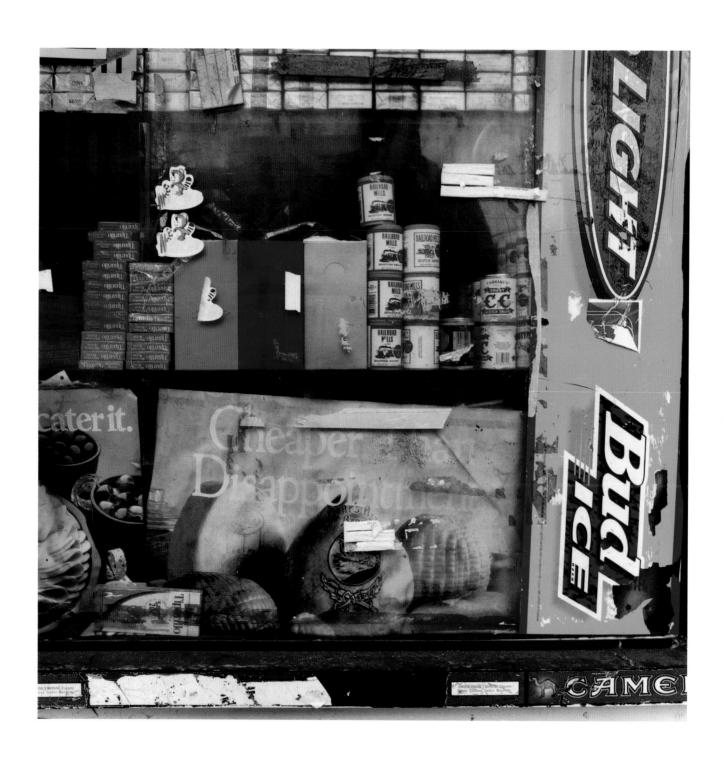

New York, New York, 2002

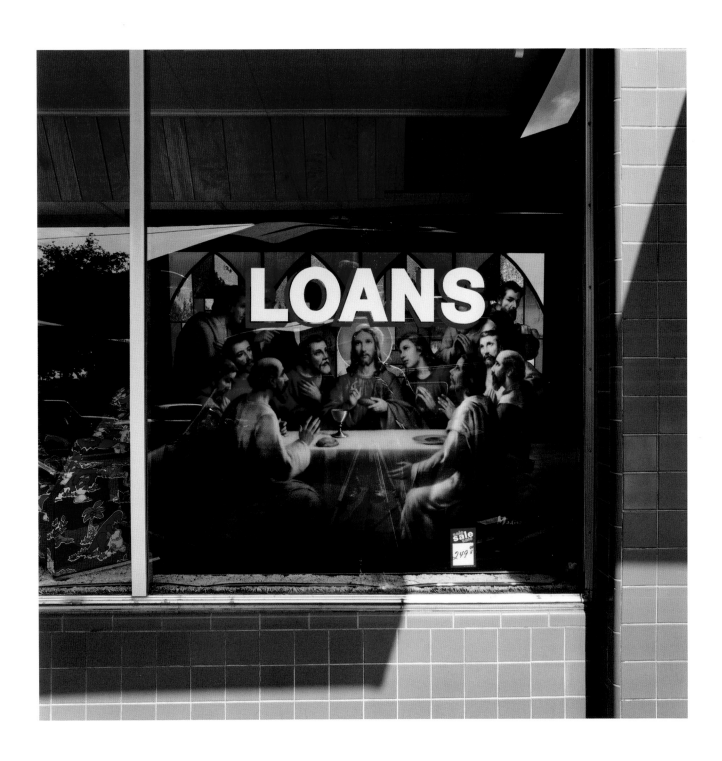

Temple, Texas, 1998

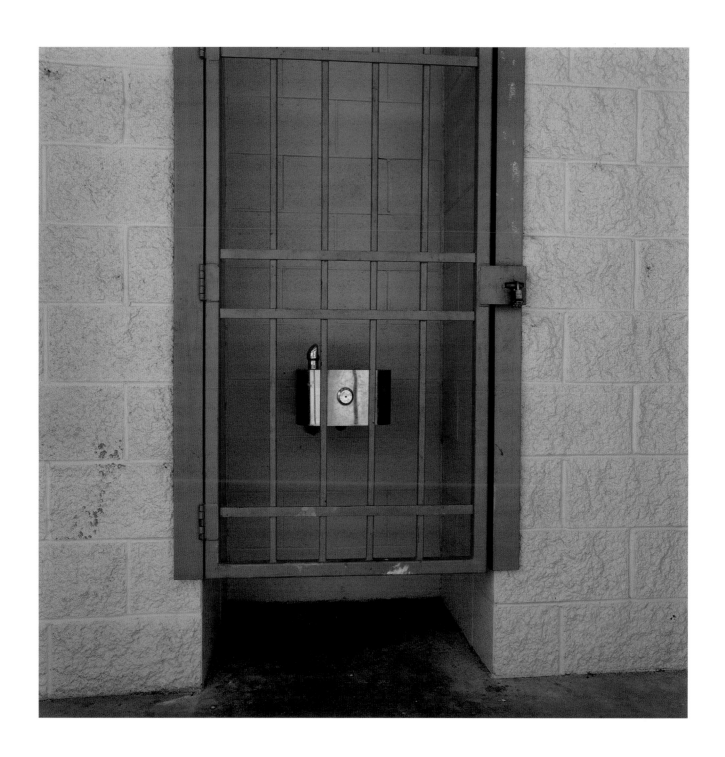

Pueblo, Colorado, 1999

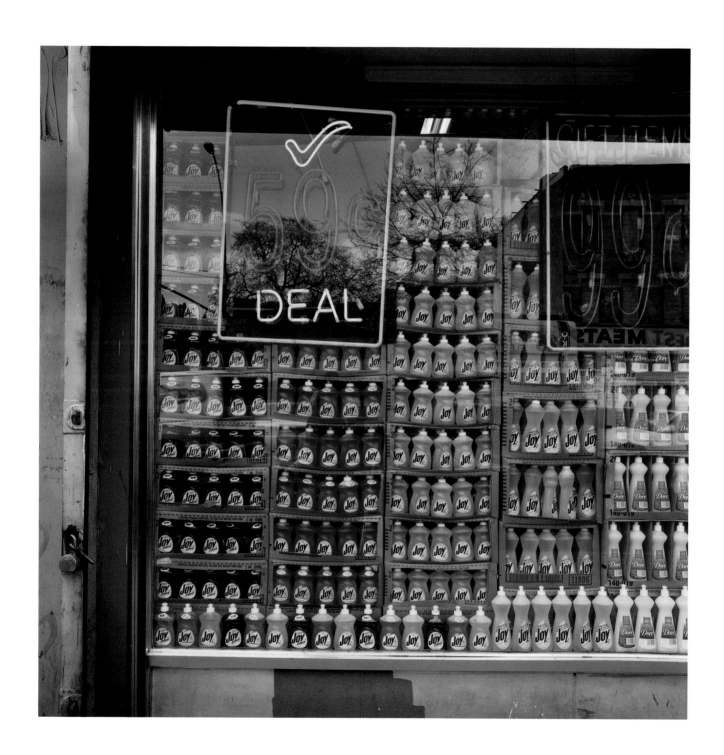

Brooklyn, New York, 2002

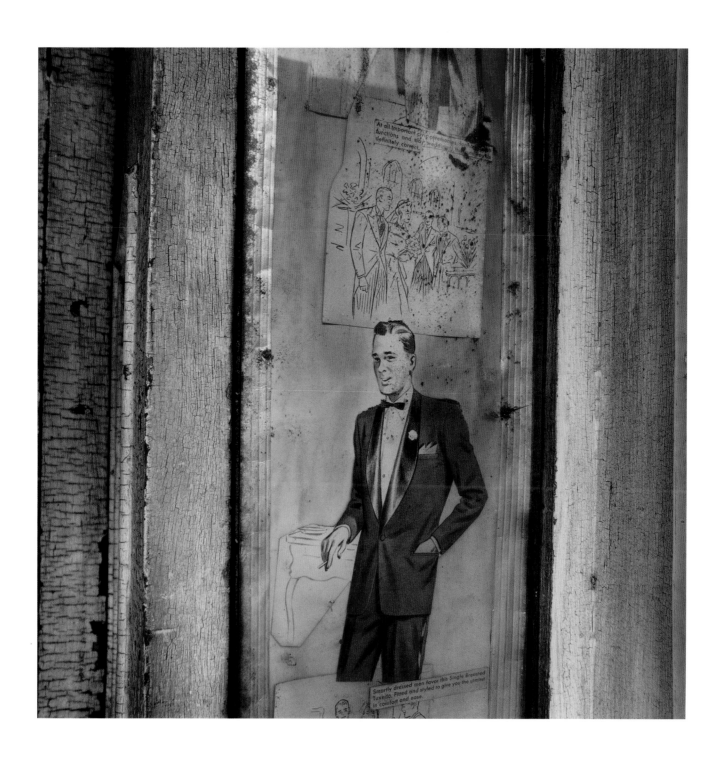

New York, New York, June 2001

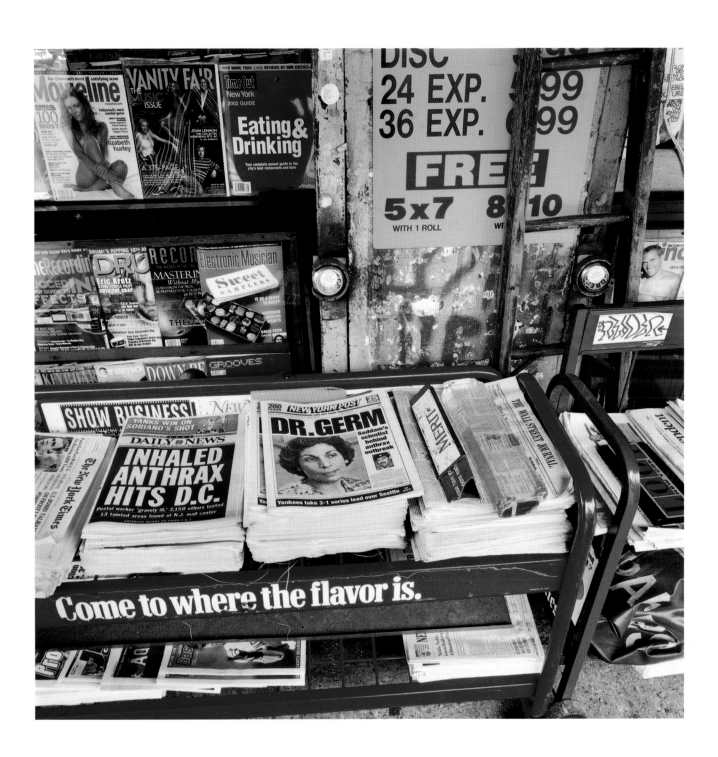

New York, New York, October 2001

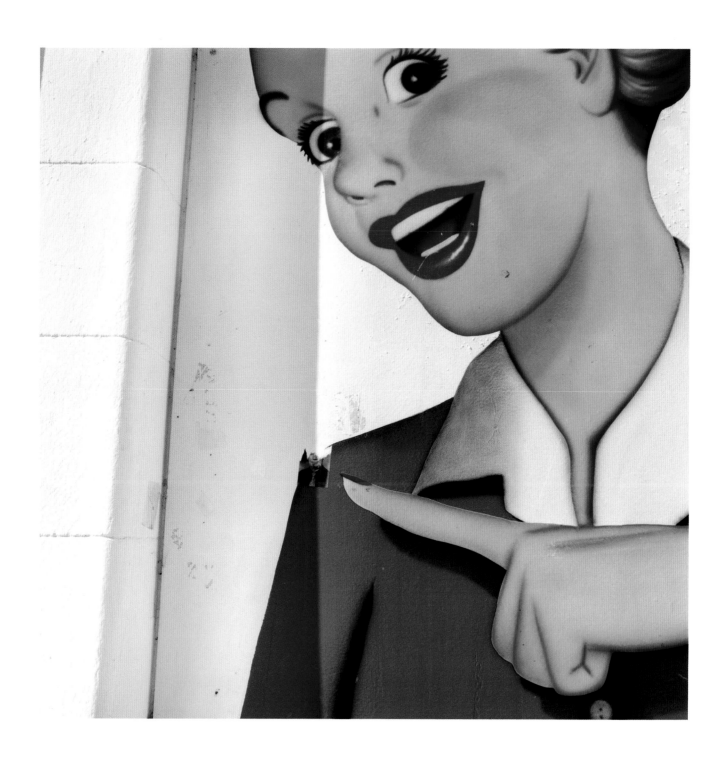

Fort Myers, Florida, 2001

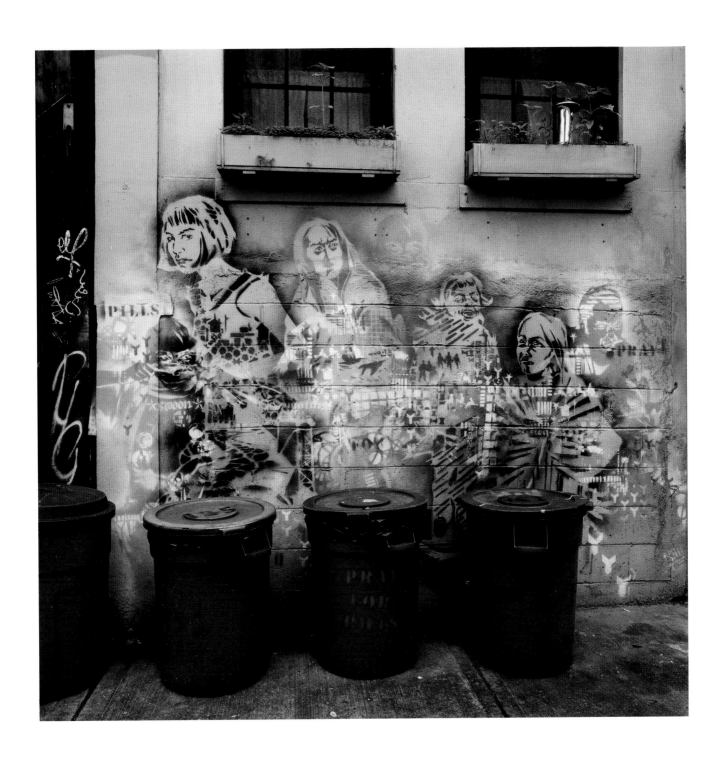

New York, New York, 2003

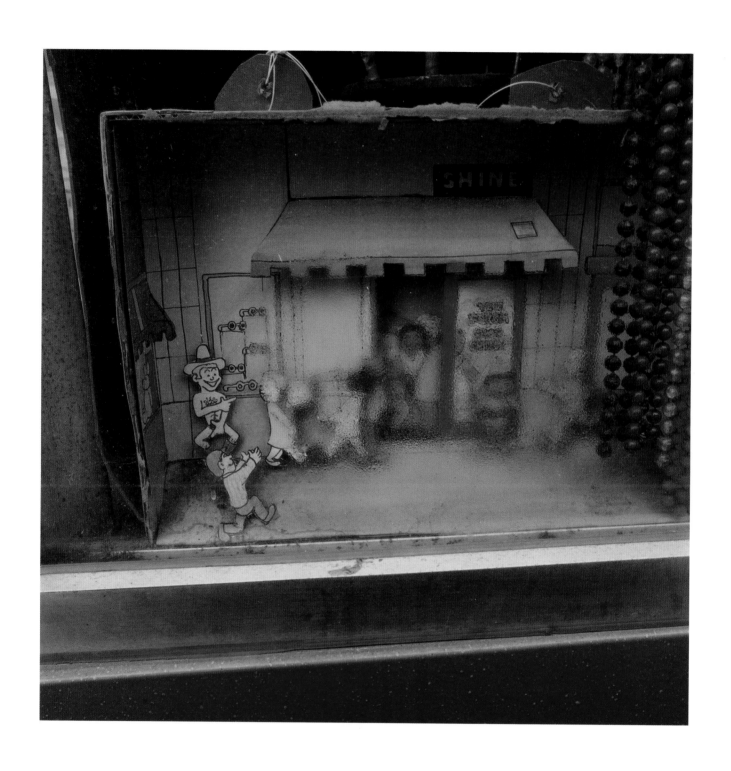

Sacramento, California, 2000

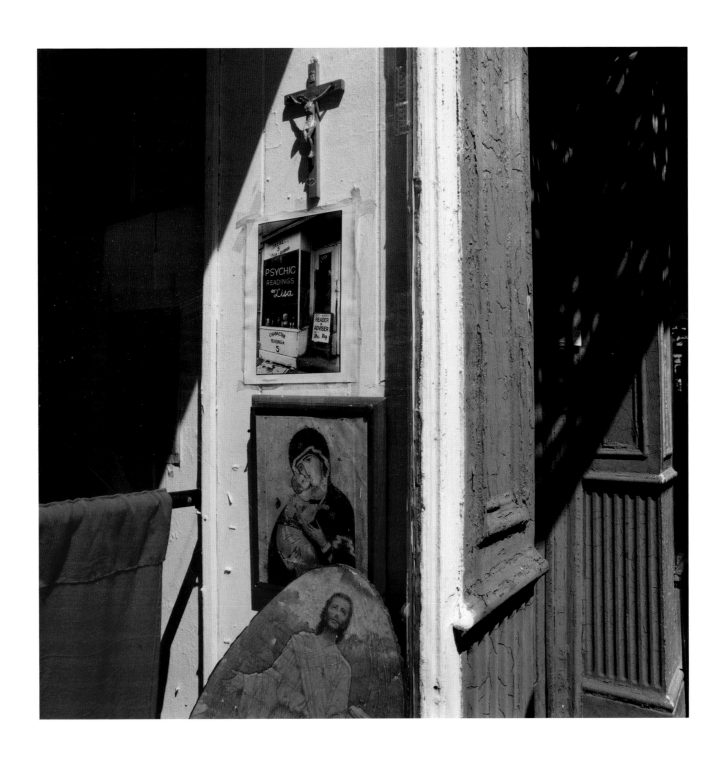

New York, New York, June 2001

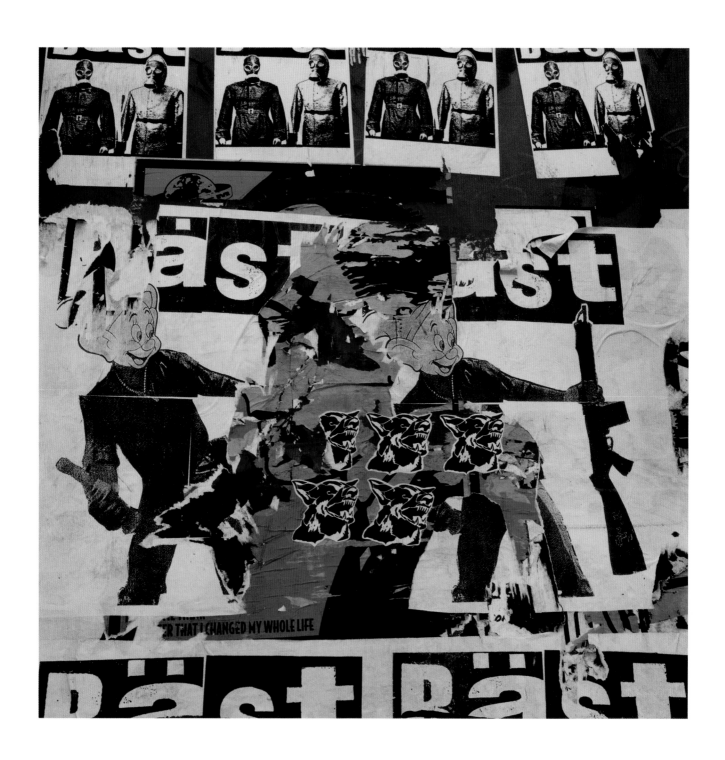

New York, New York, June 2001

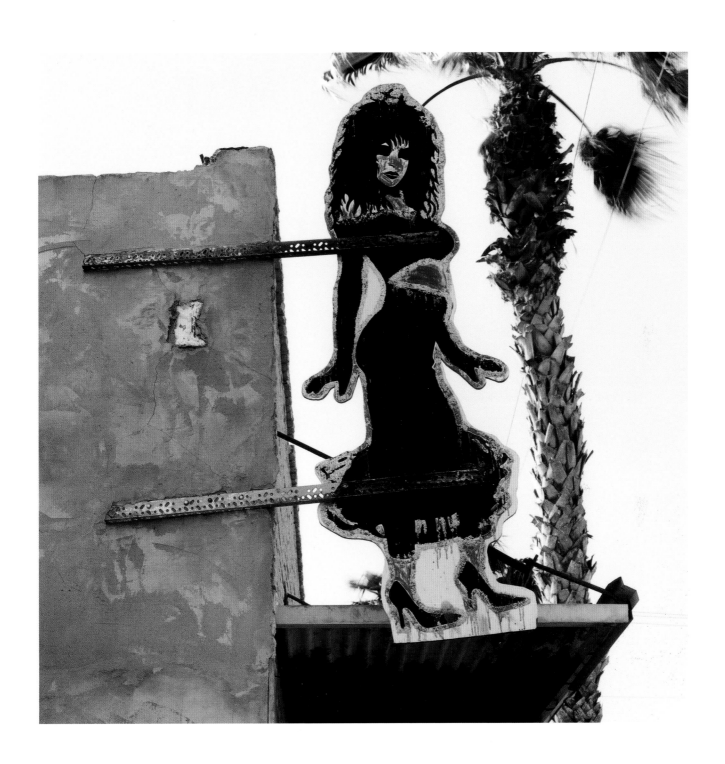

Weslaco, Texas, 1999

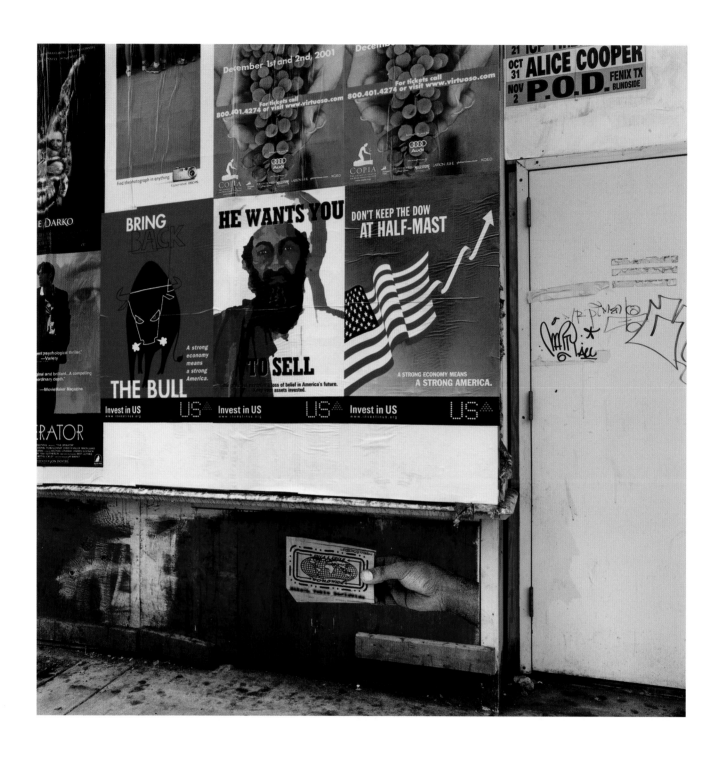

New York, New York, October 2001

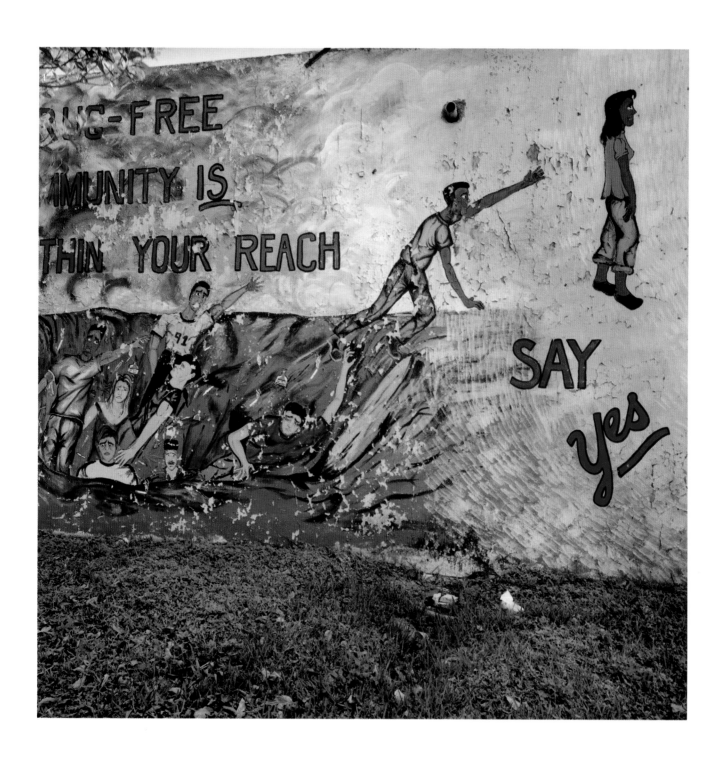

Miami (Overtown), Florida, 2001

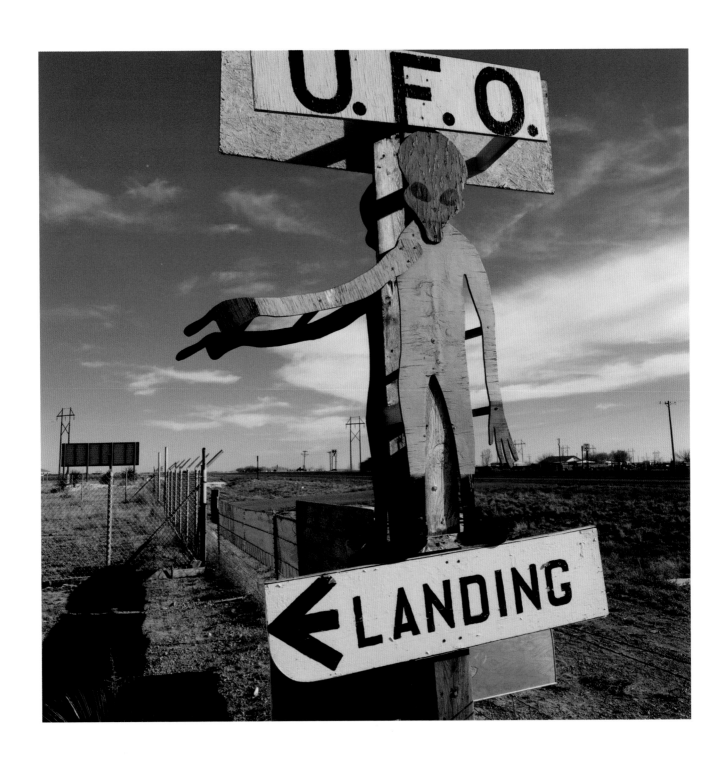

Roswell, New Mexico, 1999

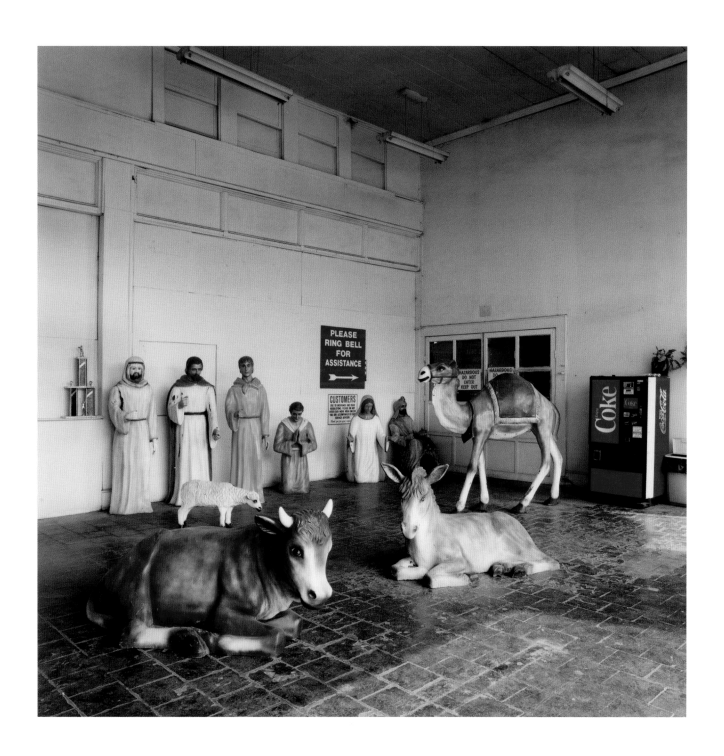

Bremen, Georgia, 1995

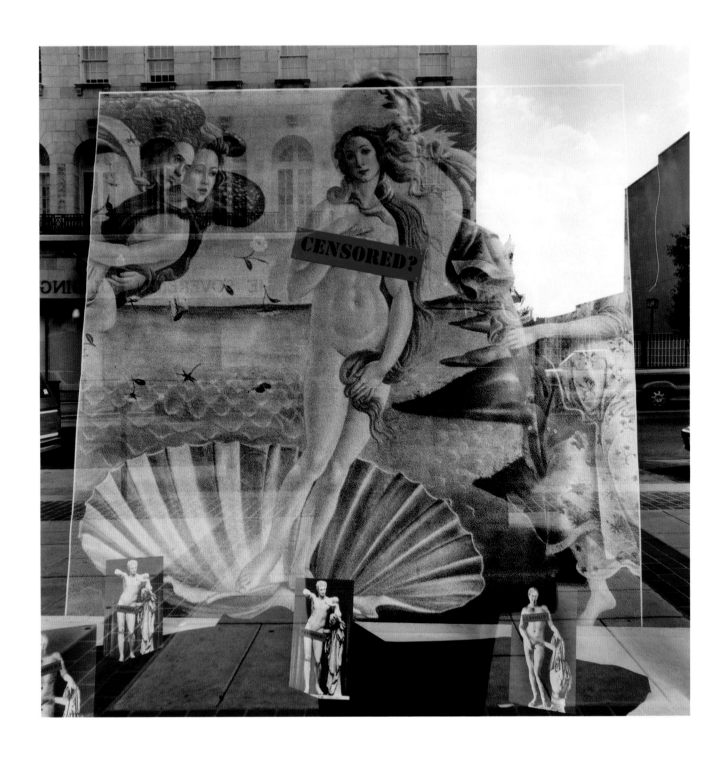

Allentown, Pennsylvania, 2002

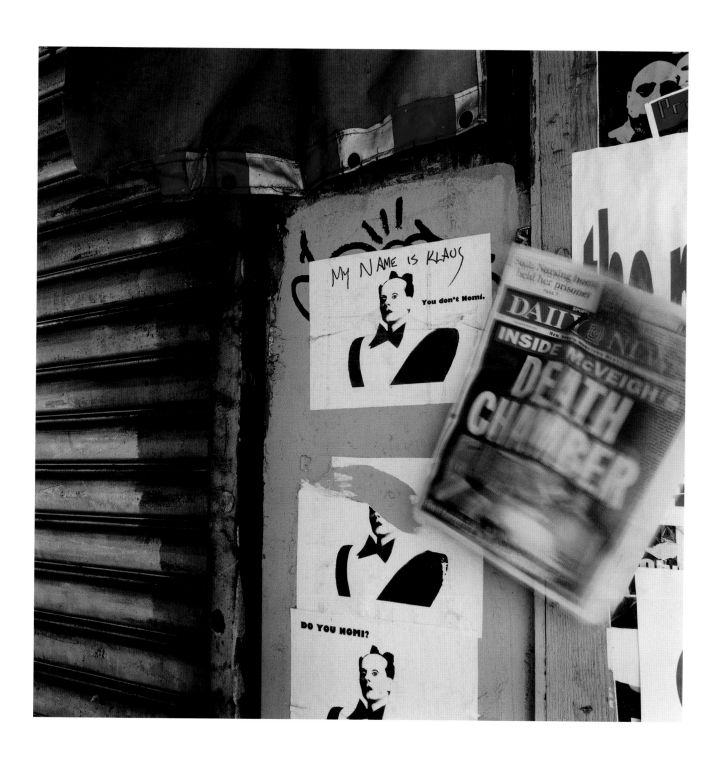

New York, New York, June 2001

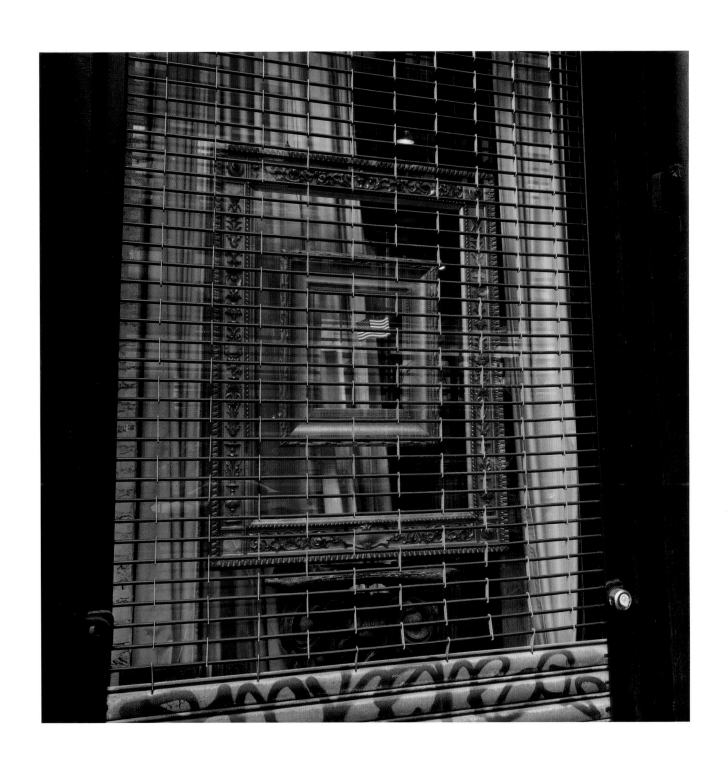

New York, New York, March 2002

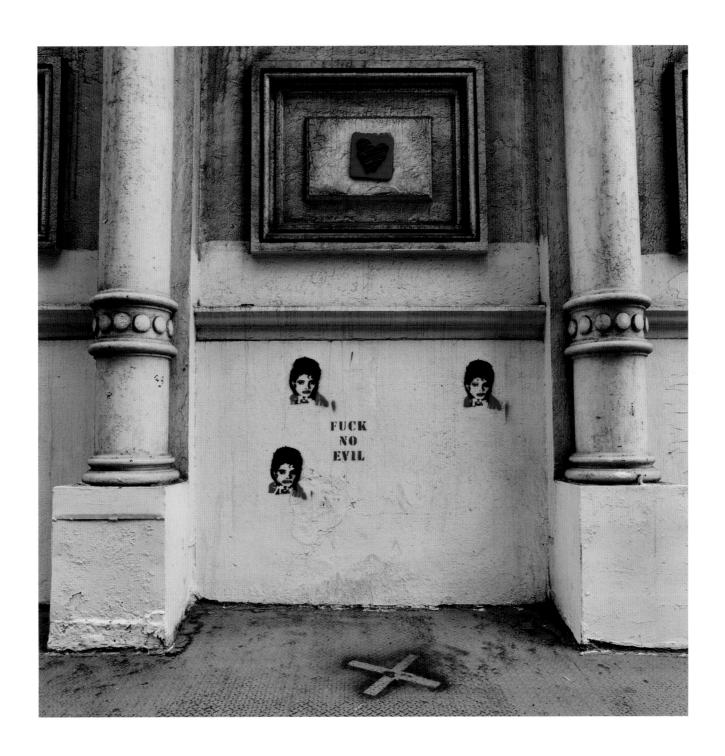

New York, New York, 2003

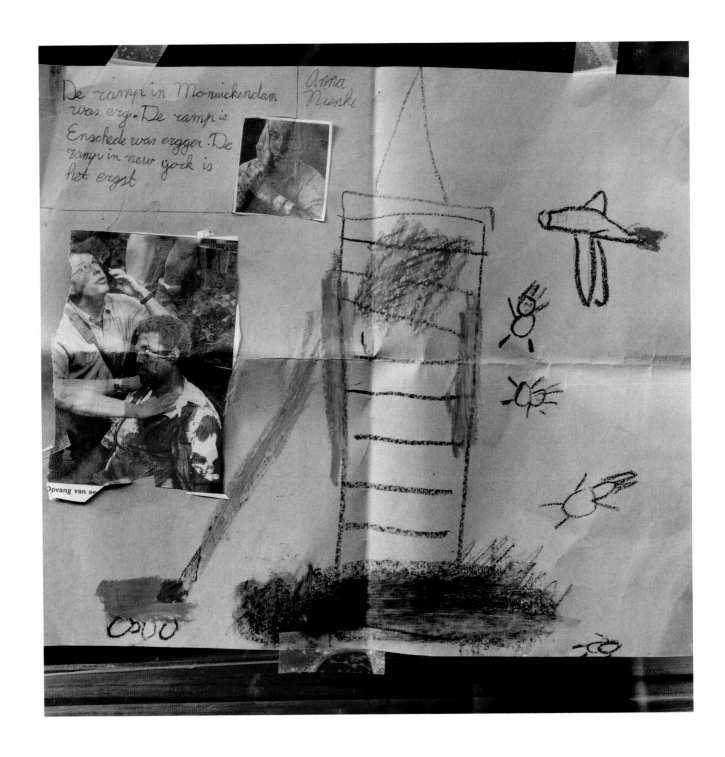

New York, New York, October 2001

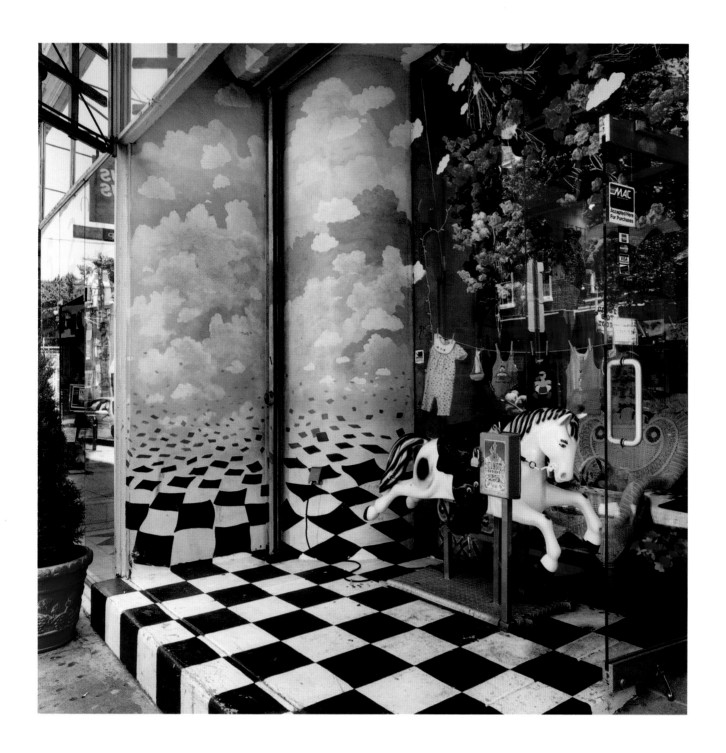

Philadelphia, Pennsylvania, 2002

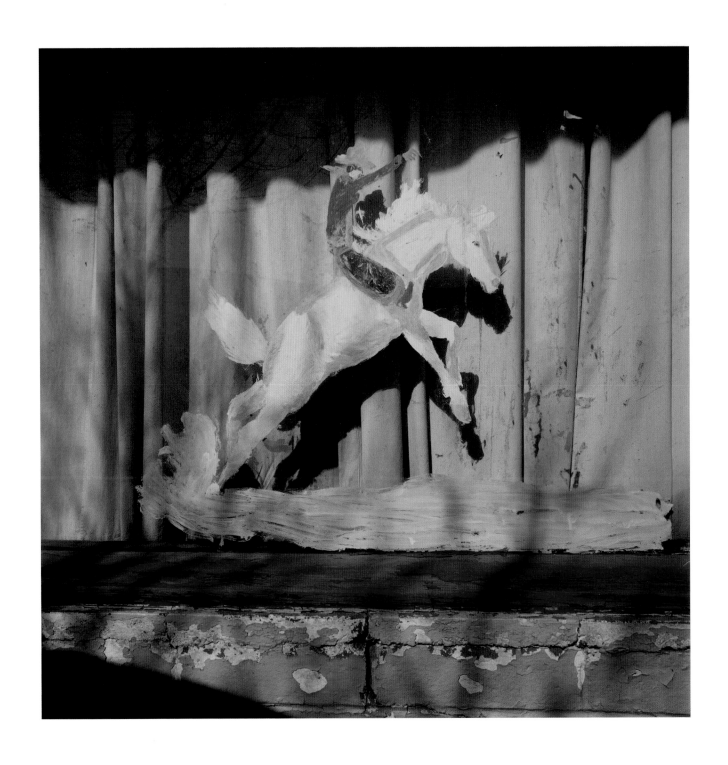

Willcox, Arizona, 1999

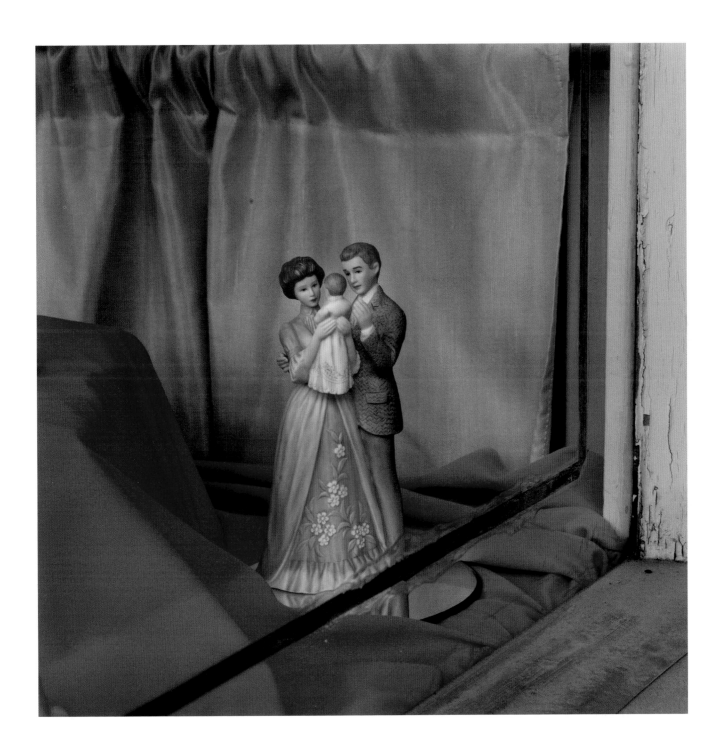

Strathroy, 1994

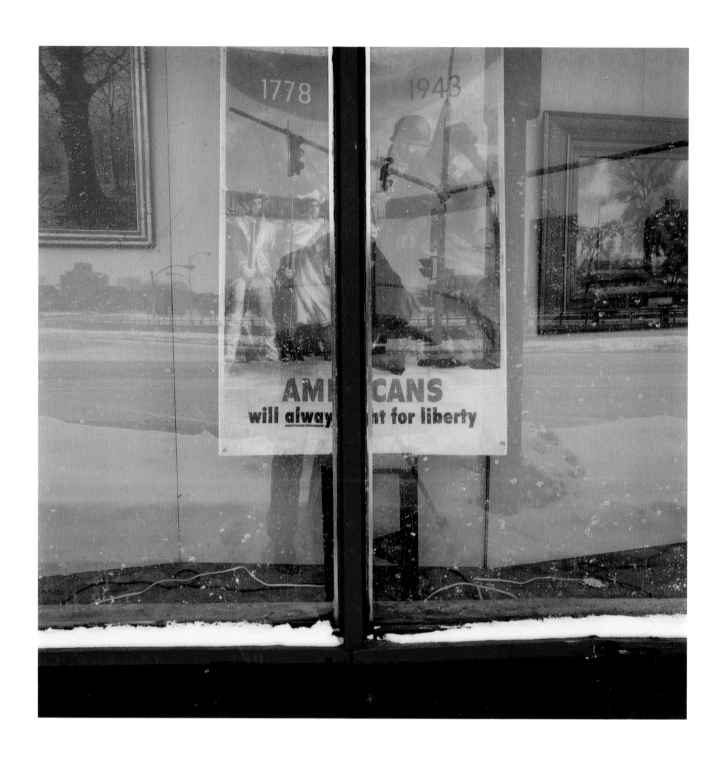

Rochester, New York, 2003

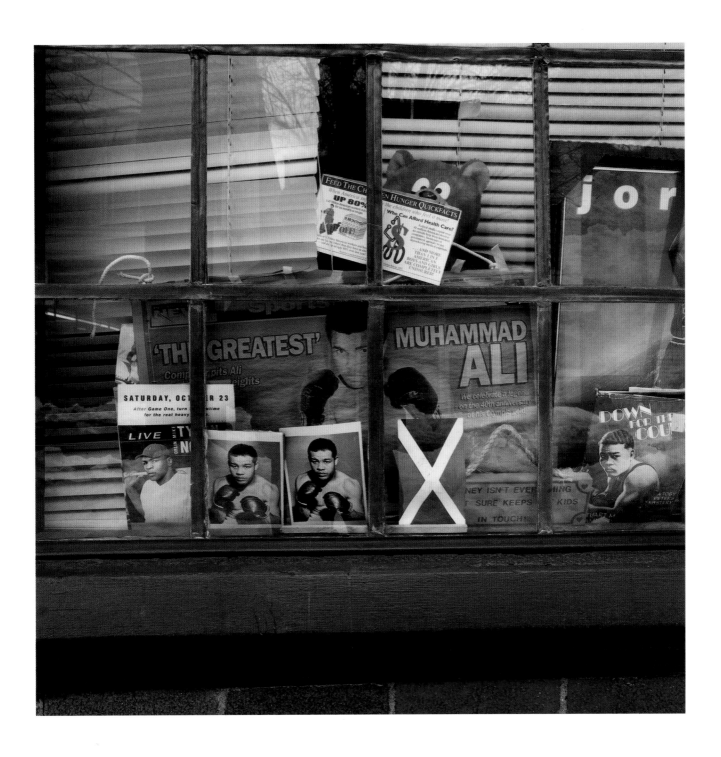

Reading, Pennsylvania, 2003

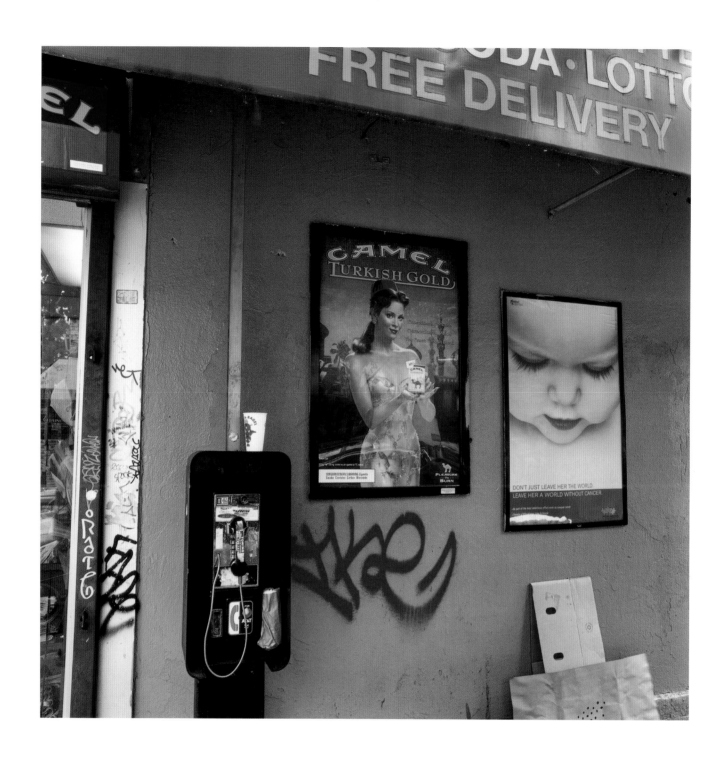

New York, New York, June 2001

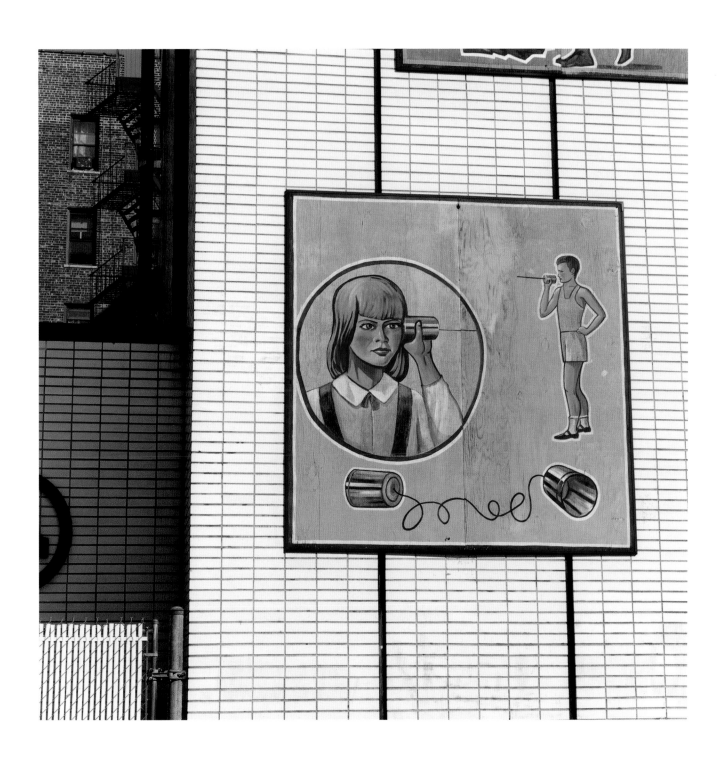

Brooklyn (Coney Island), New York, 2002

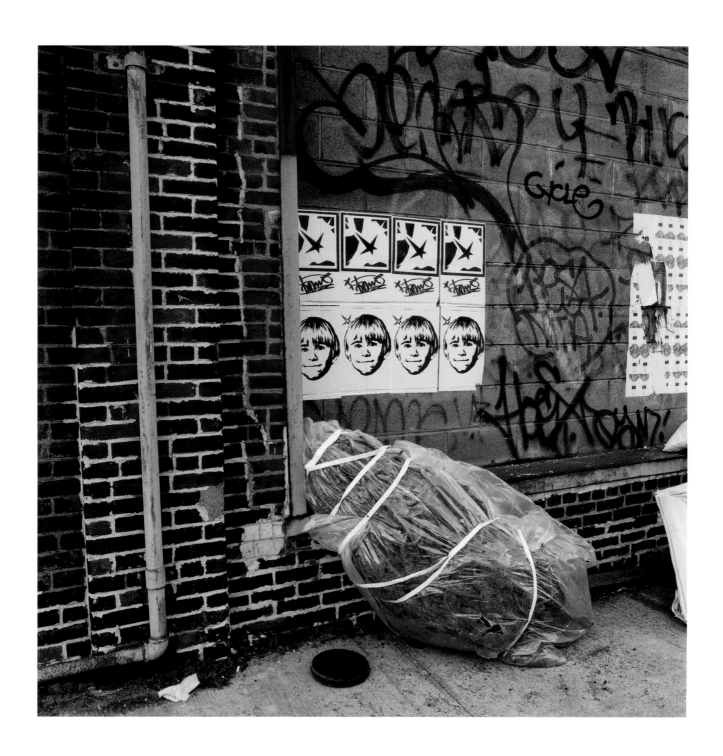

Brooklyn, New York, 2002

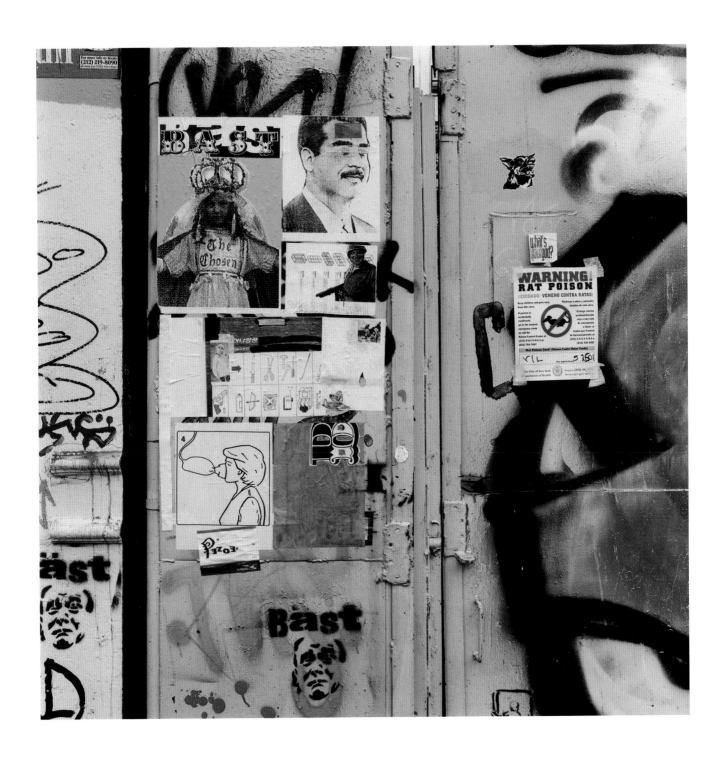

New York, New York, June 2001

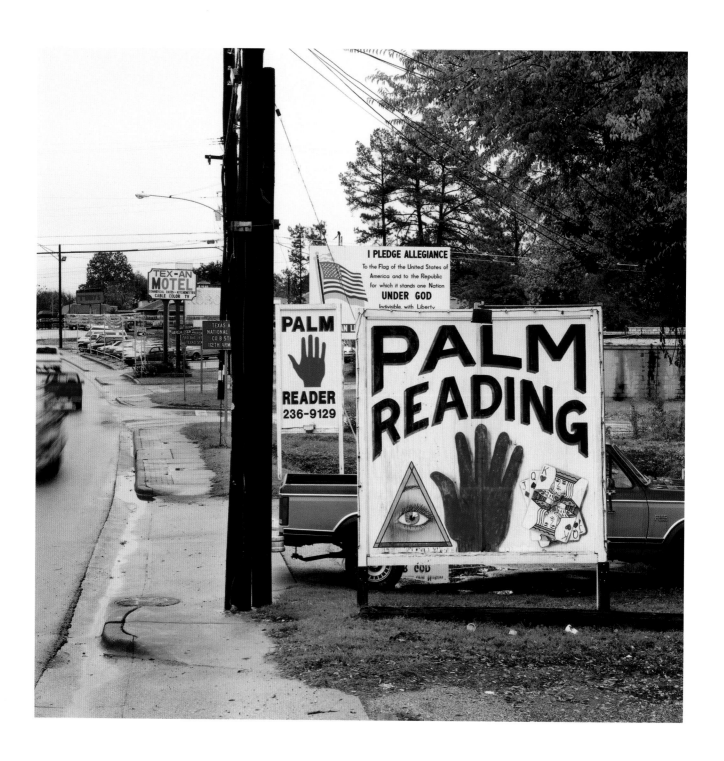

Longview, Texas, 1997

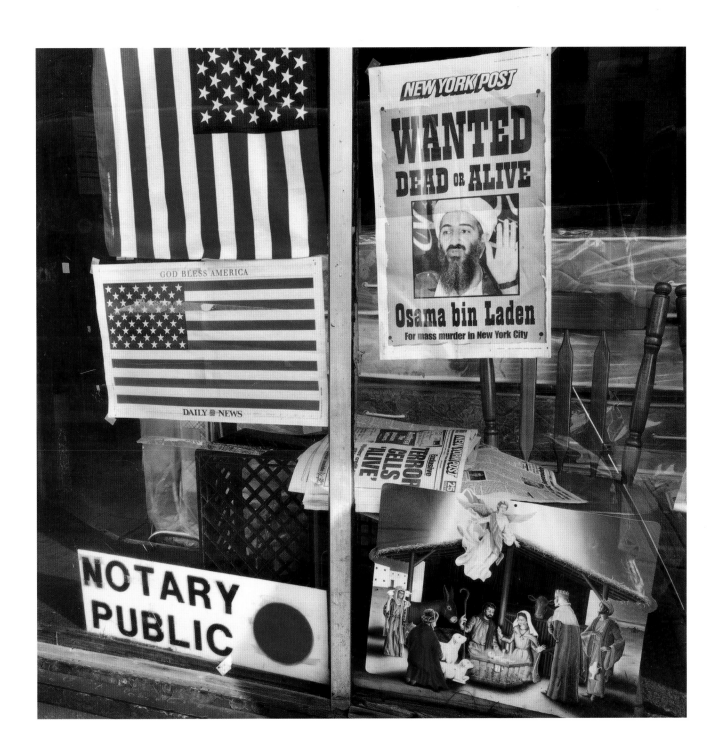

New York, New York, October 2001

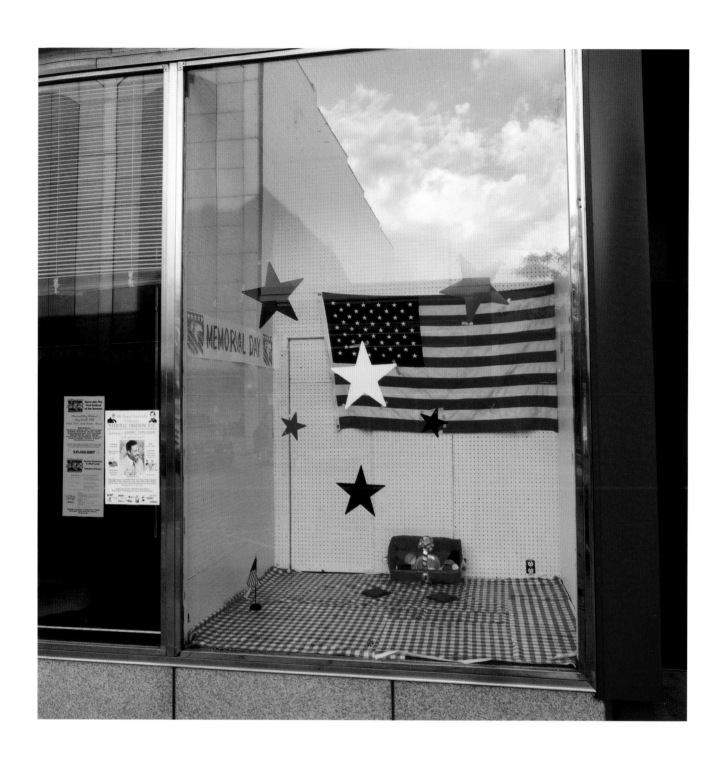

Decatur, Illinois, 1998

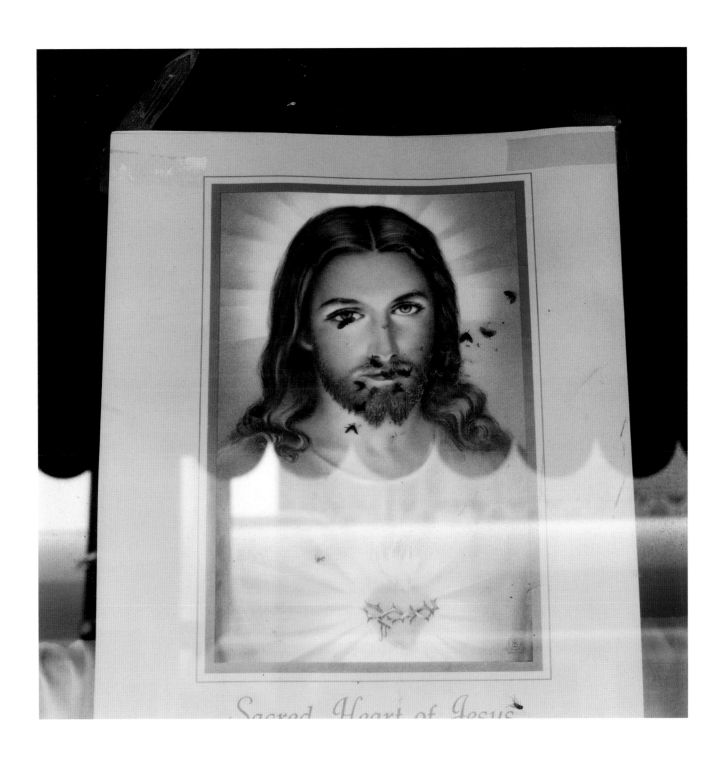

Munroe, Michigan, 1998

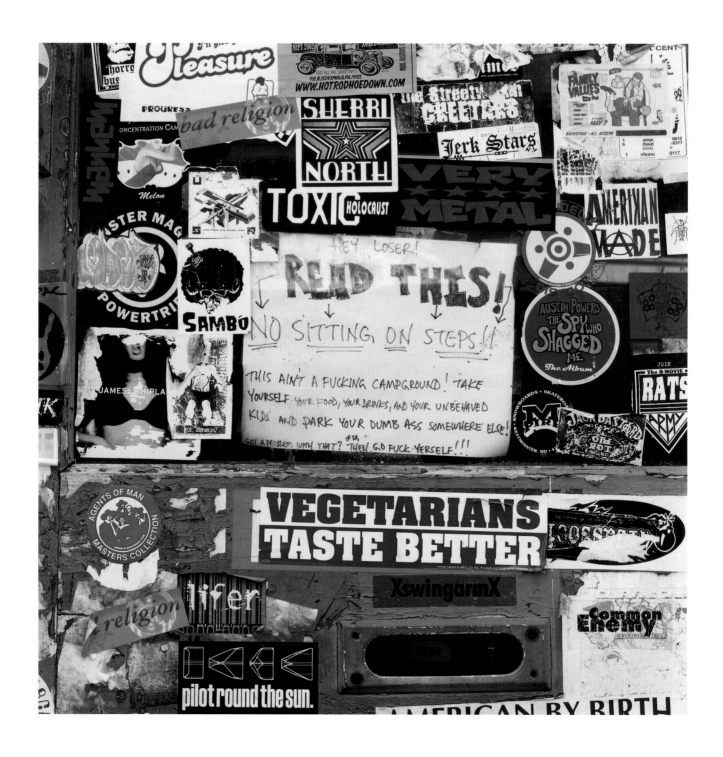

Philadelphia, Pennsylvania, 2002

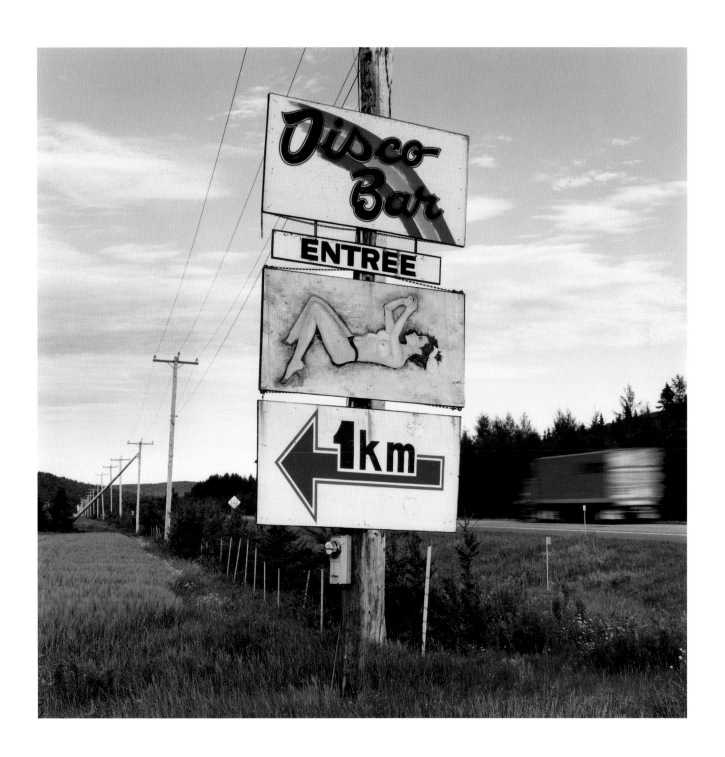

Madawaska, Maine, 1996

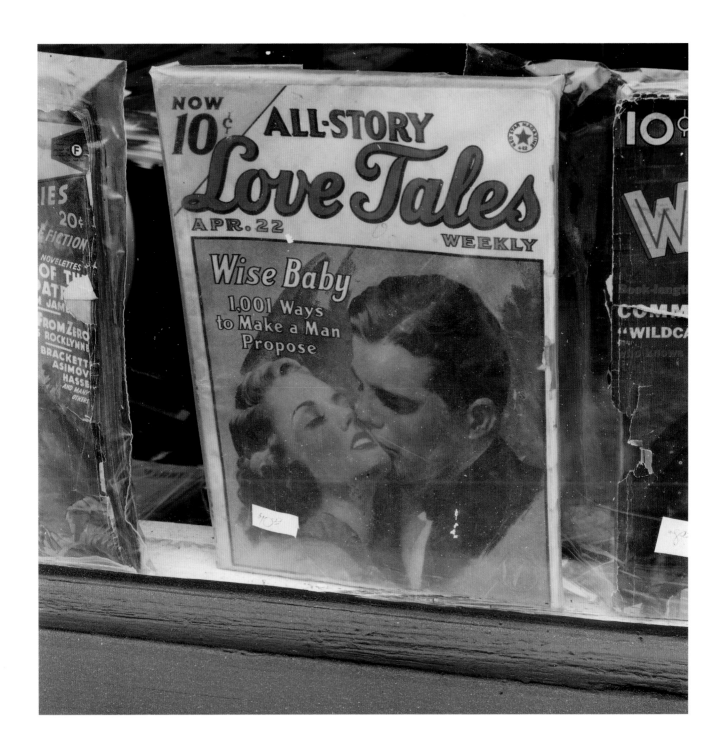

Daytona Beach, Florida, 2001

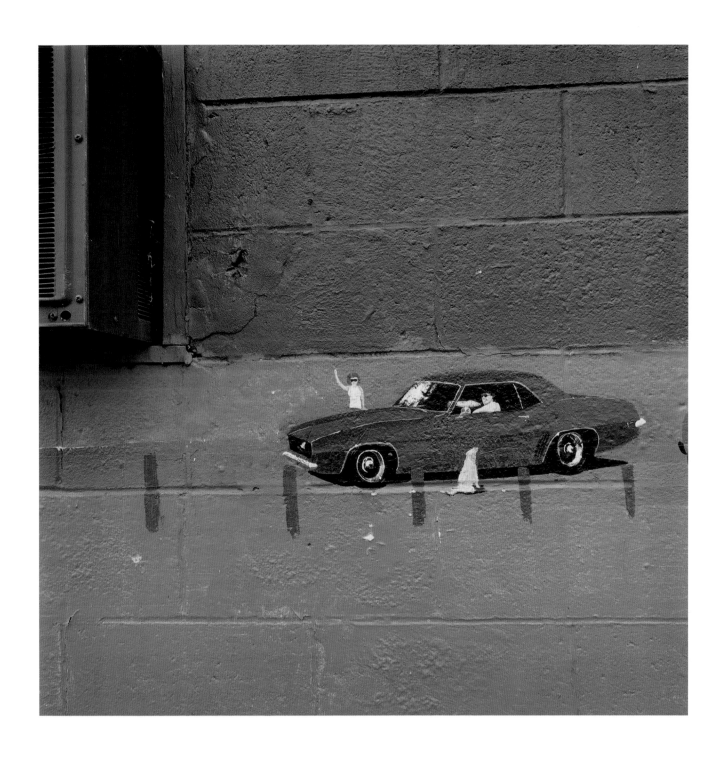

Binghamton, New York, 2002

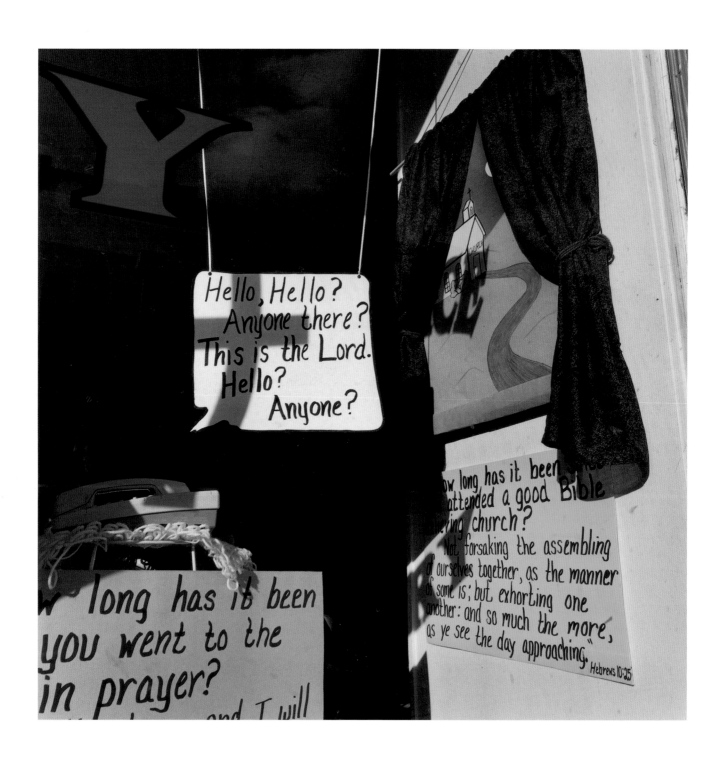

Frederick, Maryland, 1997

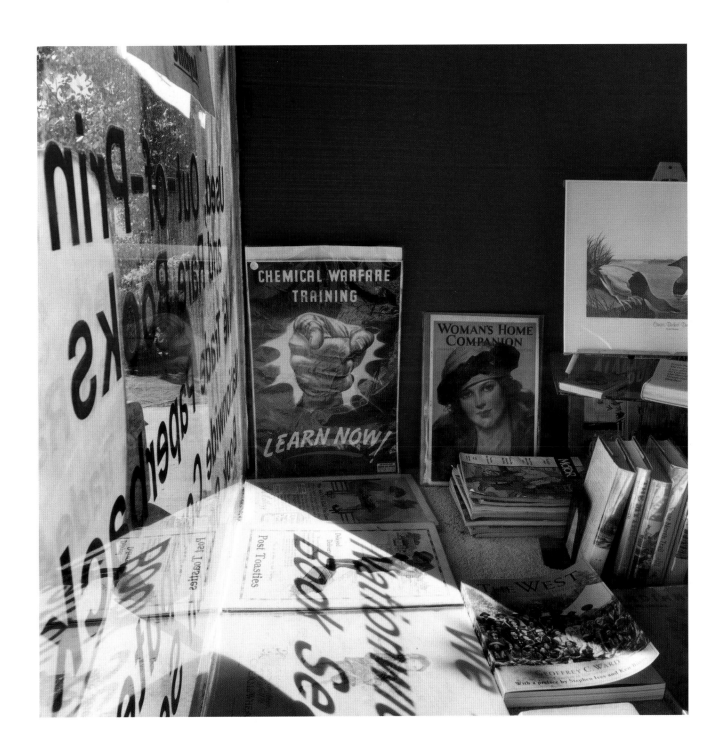

Fort Smith, Arkansas, 1998

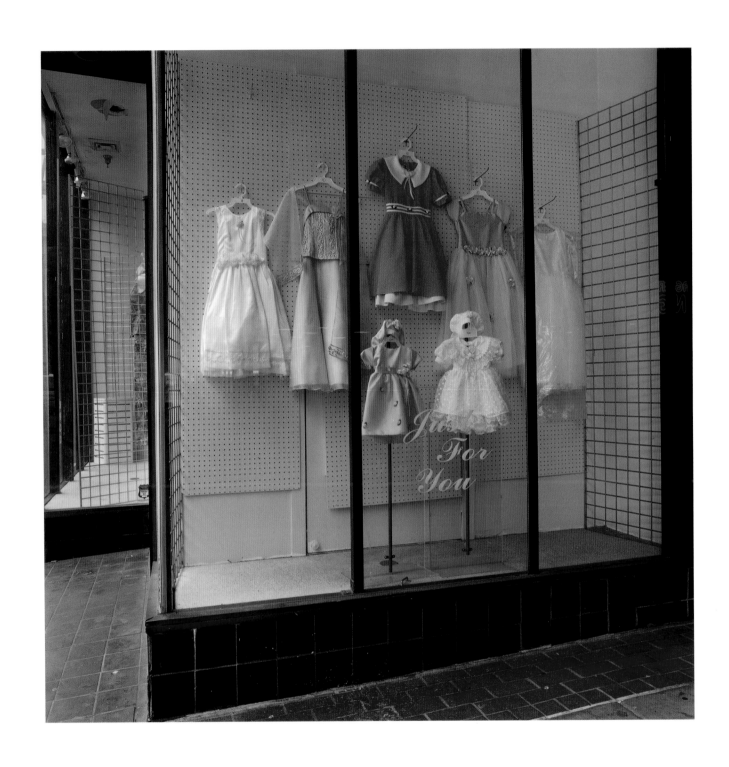

New Haven, Connecticut, 2002

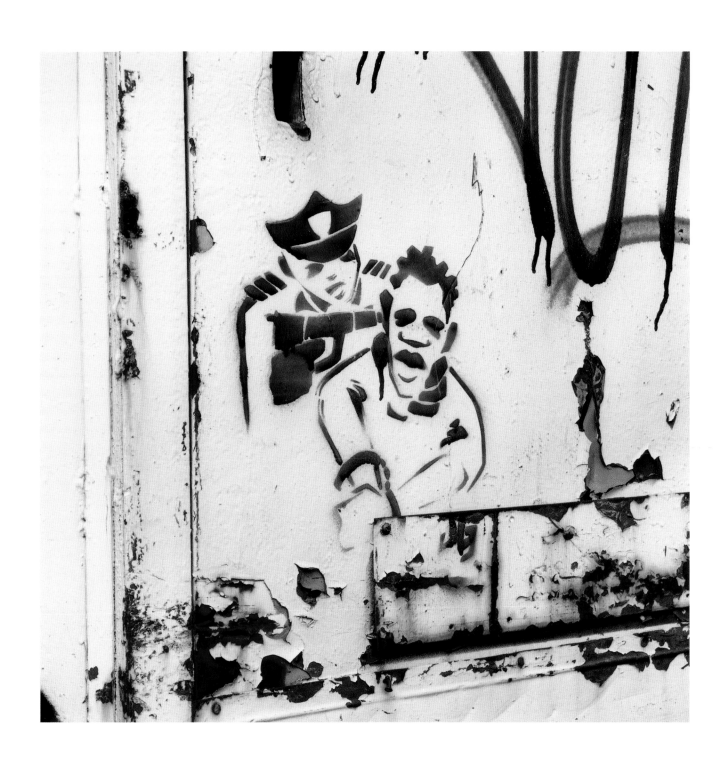

New York, New York, 2002

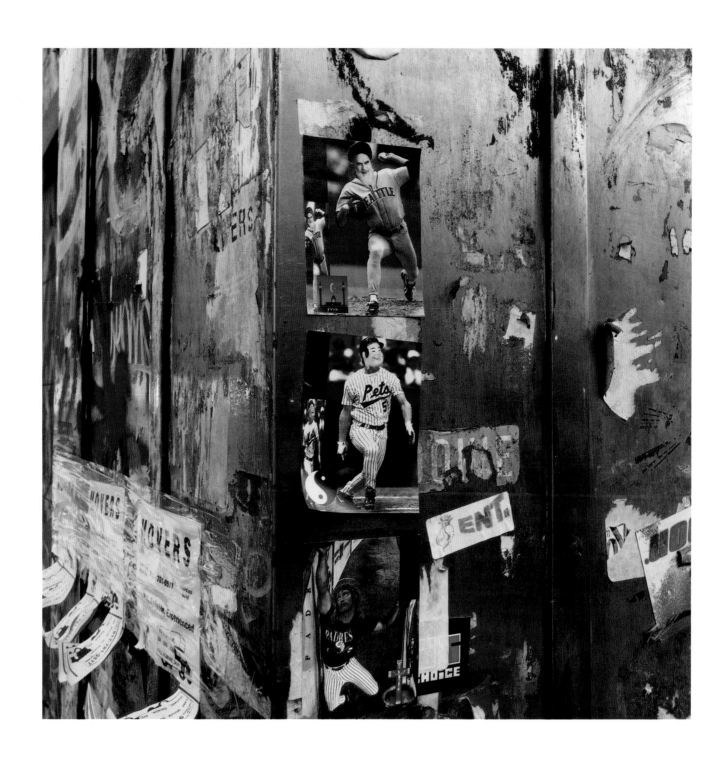

New York, New York, October 2001

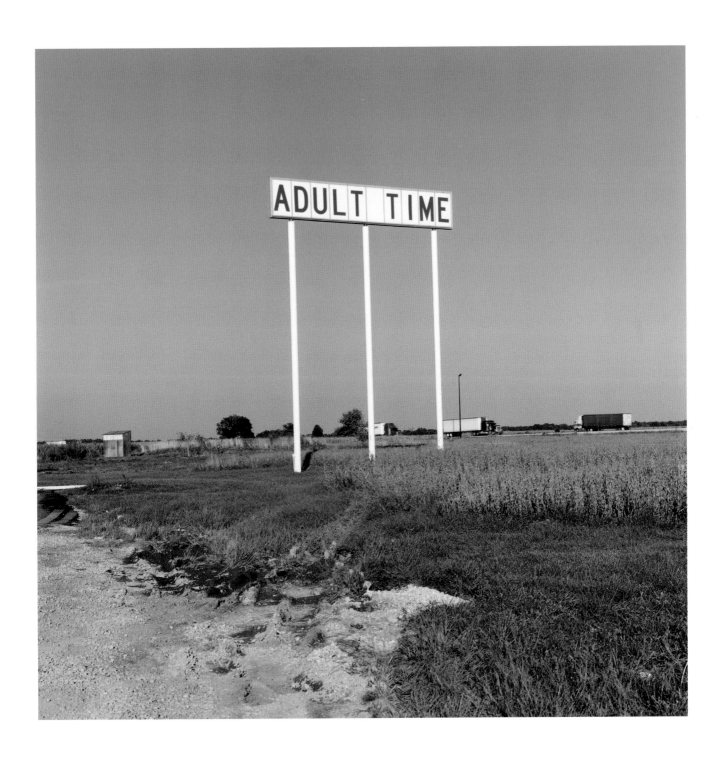

Edgewood, Illinois, 1997

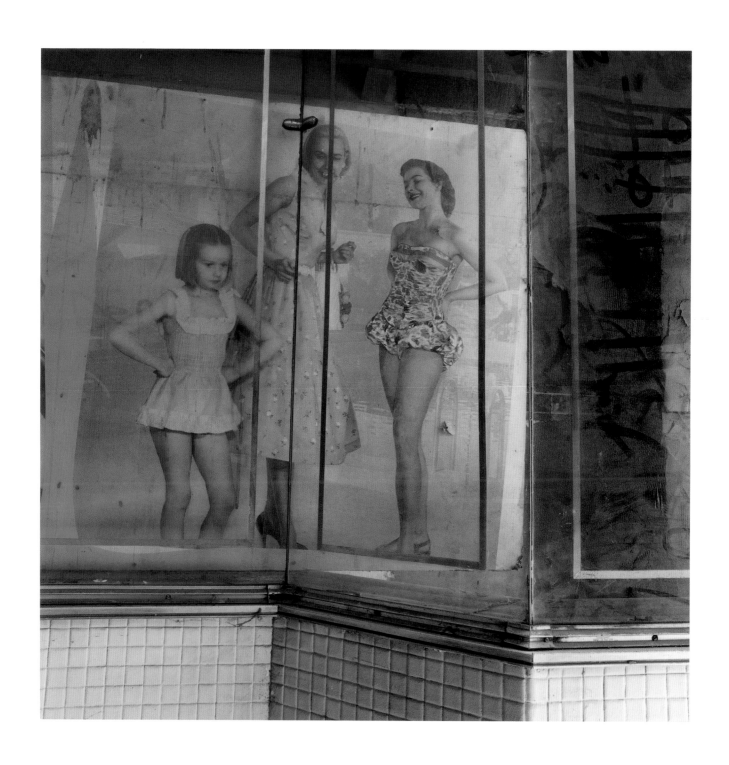

Hagerstown, Maryland, 2002

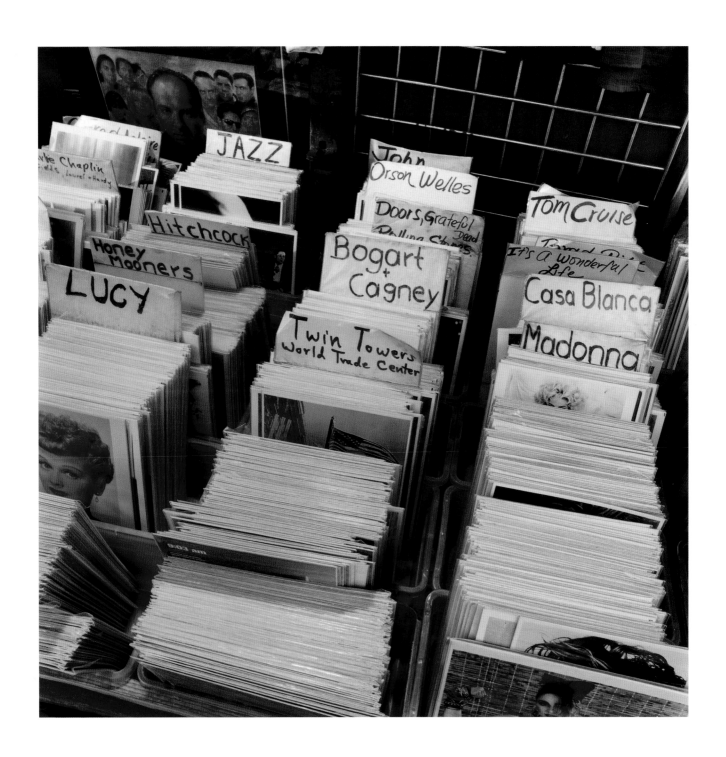

New York, New York, 2002

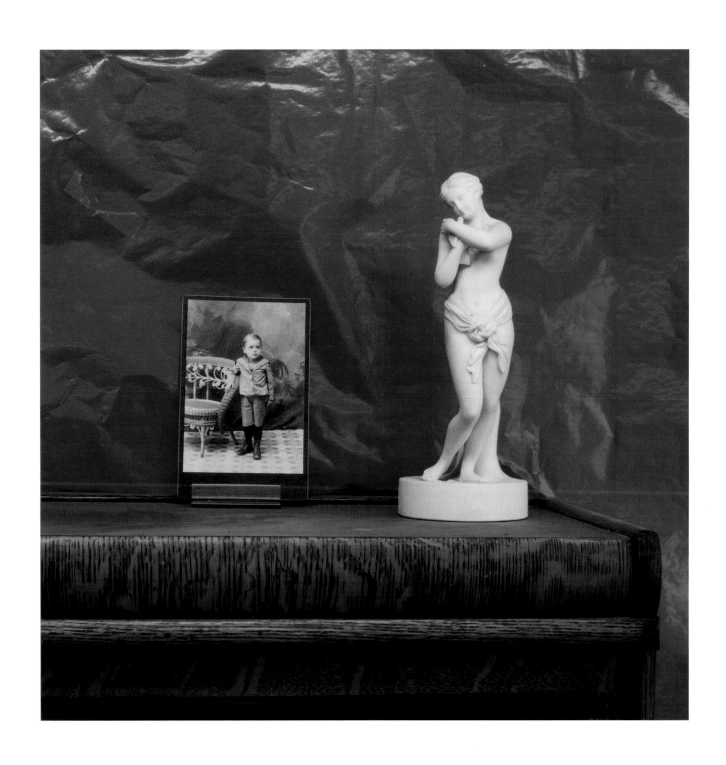

Watertown, New York, 1992

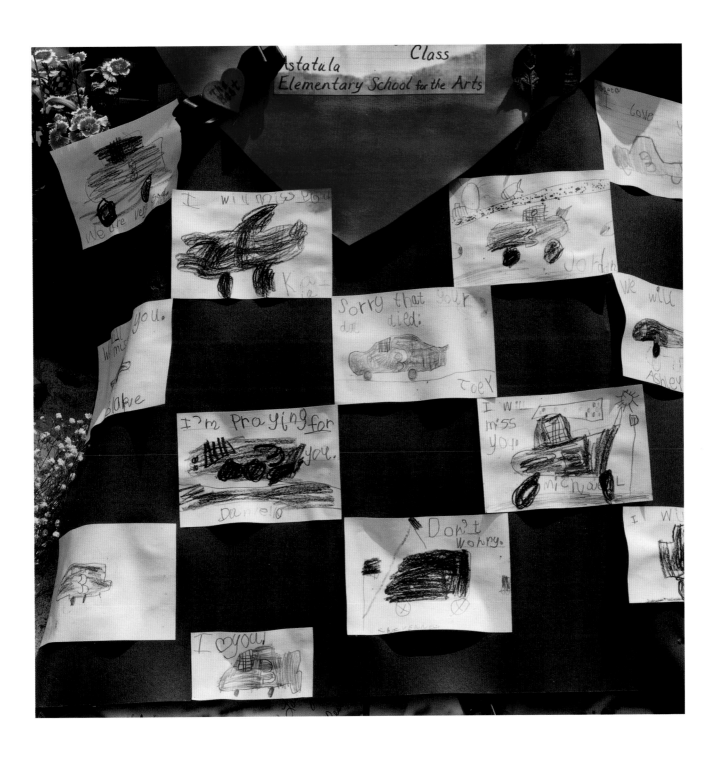

Daytona Beach, Florida, 2001

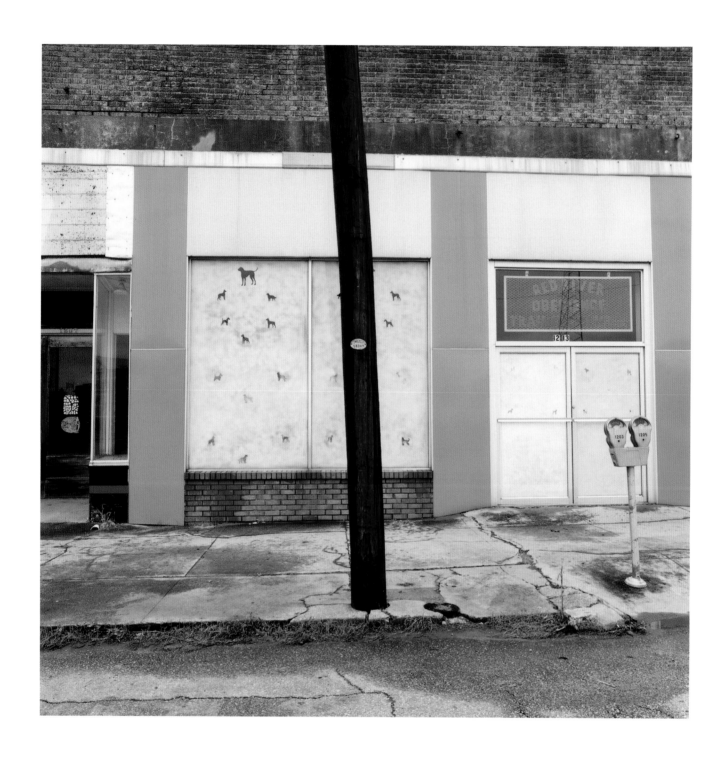

Shreveport, Louisiana, 1997

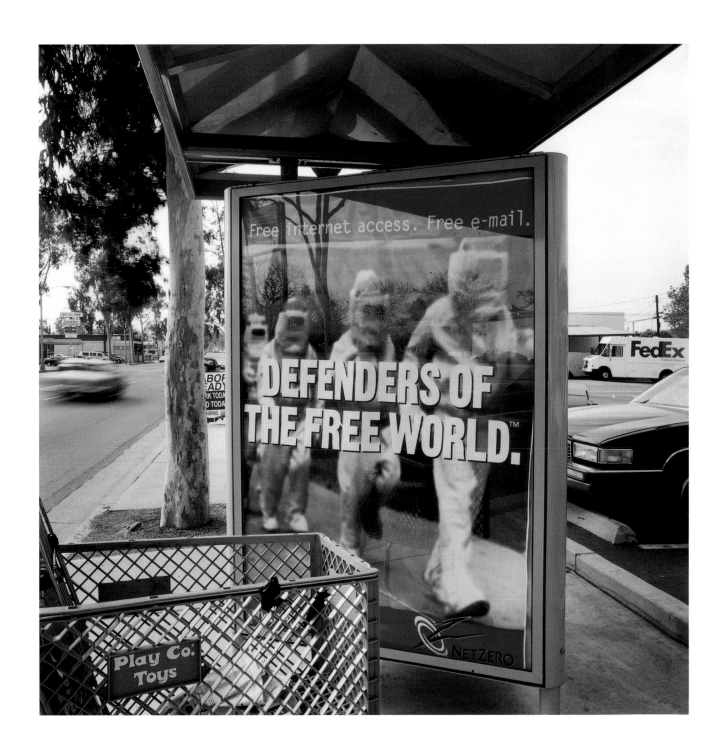

Corona, California, 2000

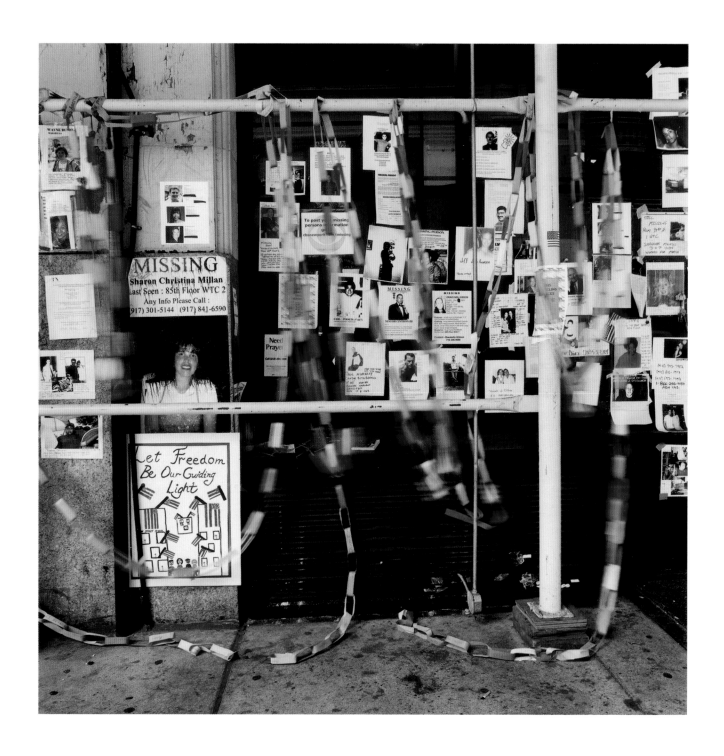

New York, New York, October 2001

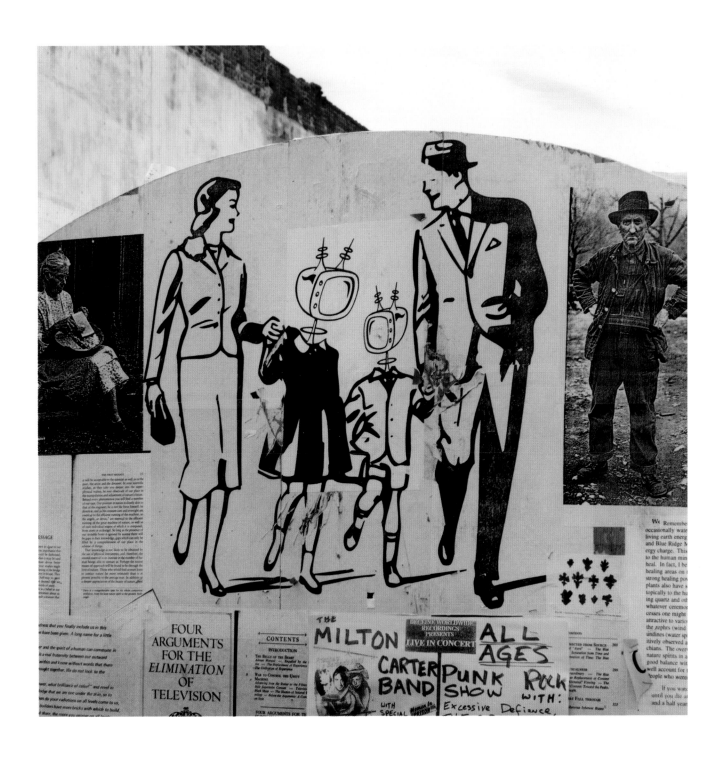

Asheville, North Carolina, 1996

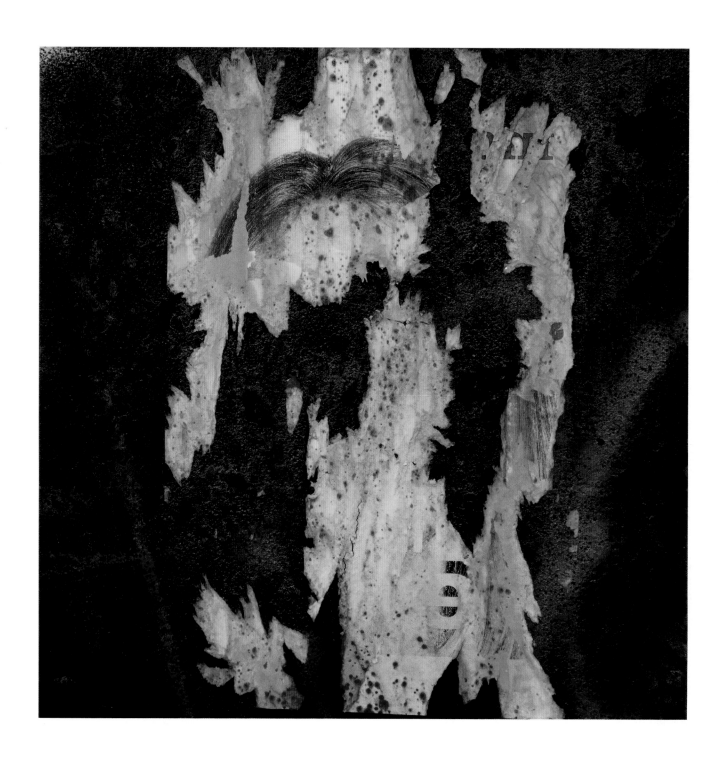

Brooklyn, New York, 2002

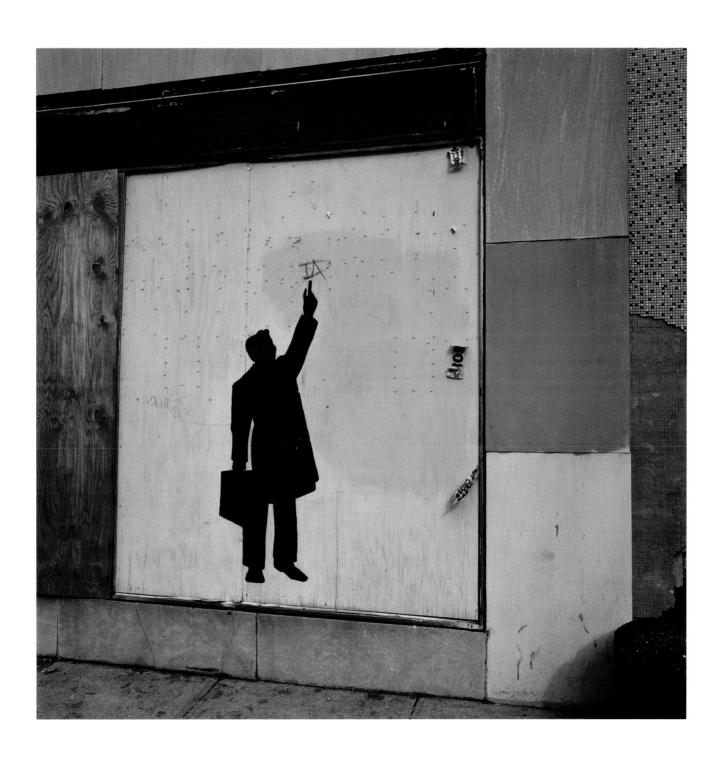

Bridgeport, Connecticut, 2002

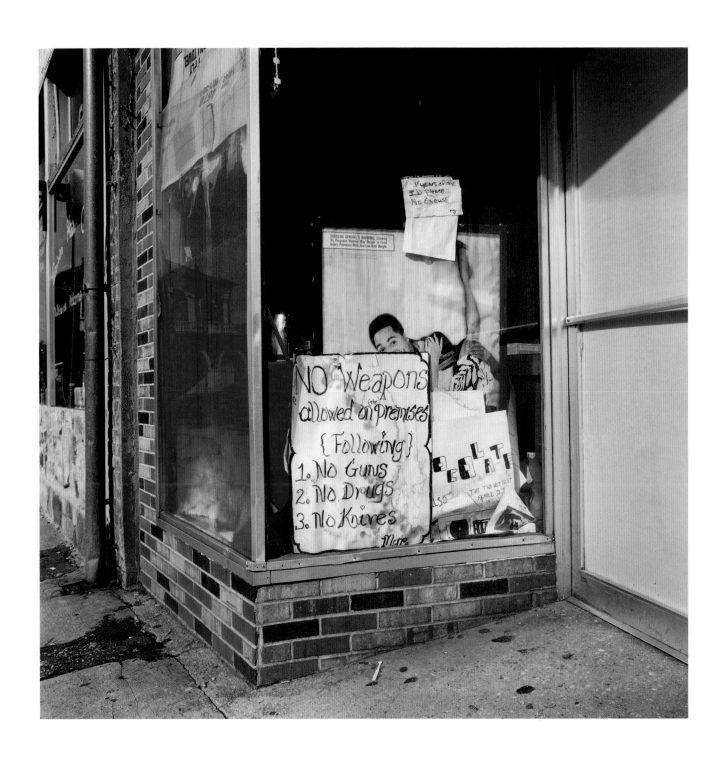

Fayetteville, North Carolina, 1996

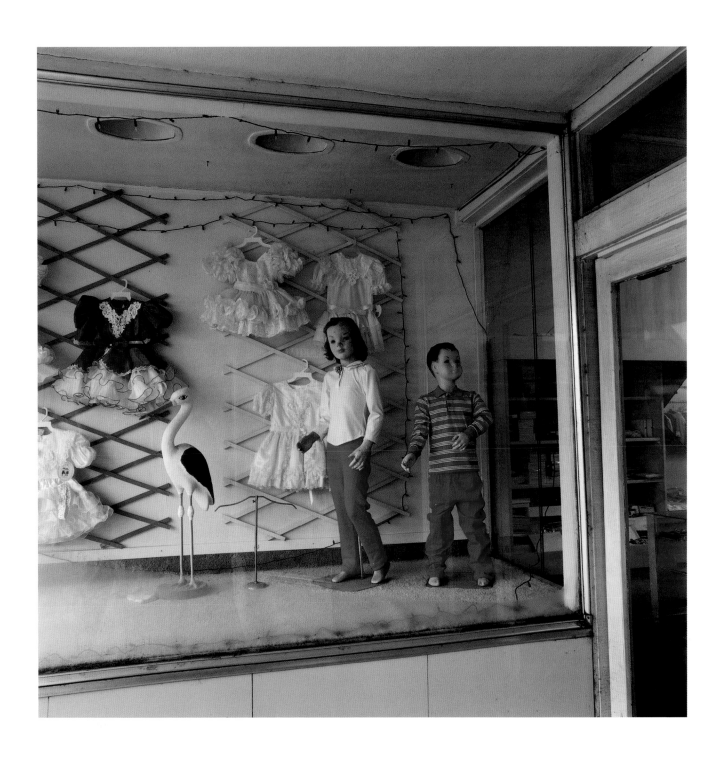

Malvern, Arkansas, 1997

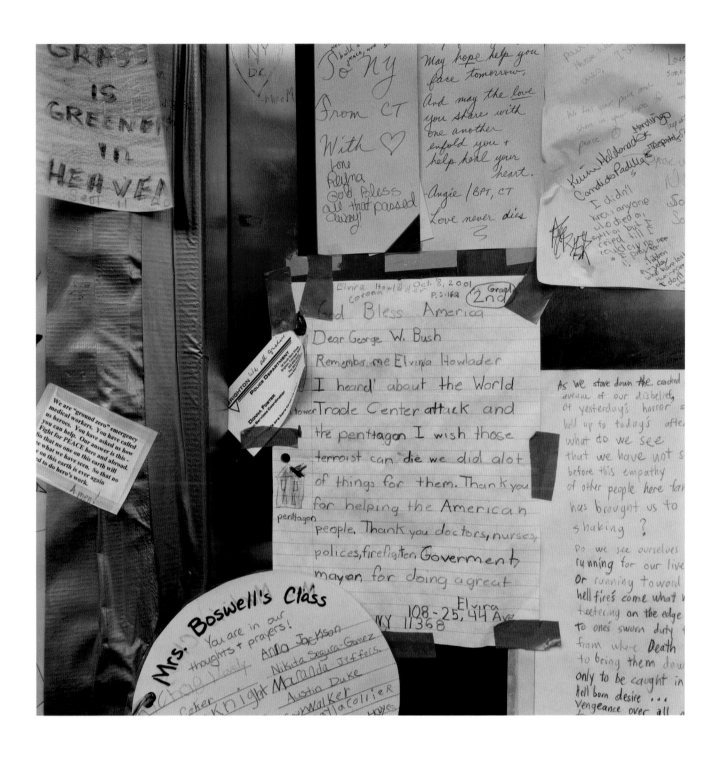

New York, New York, October 2001

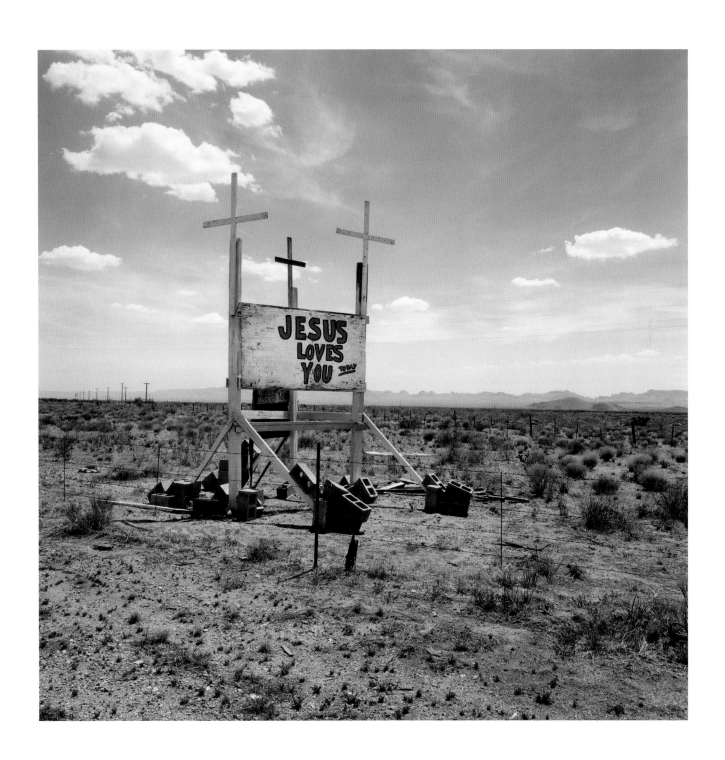

Near Kingman, Arizona, 1999

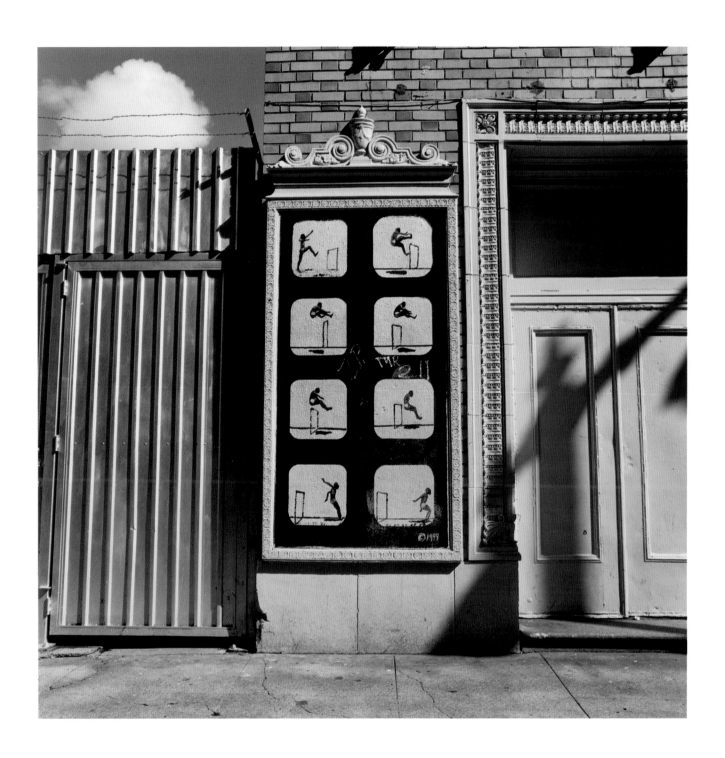

San Francisco, California, 2000

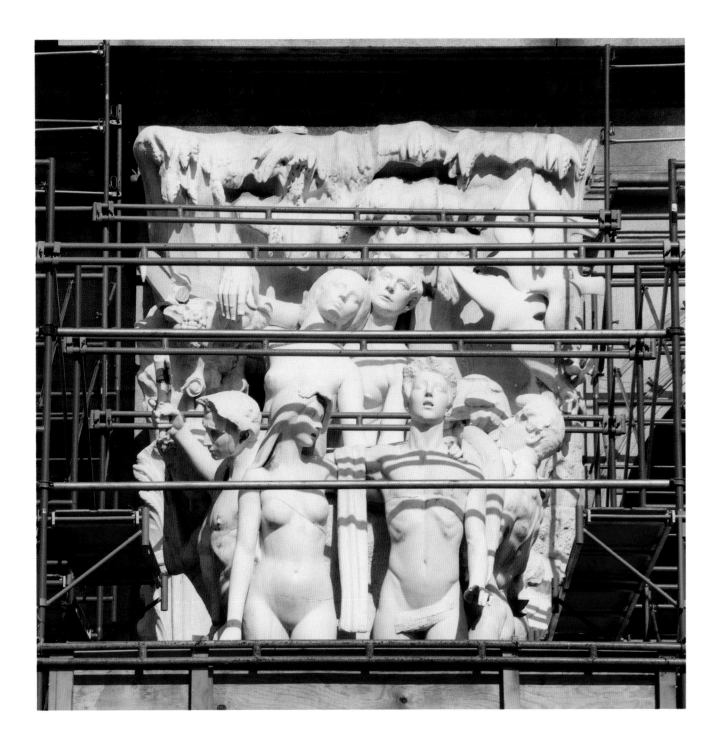

Harrisburg, Pennsylvania, 1992

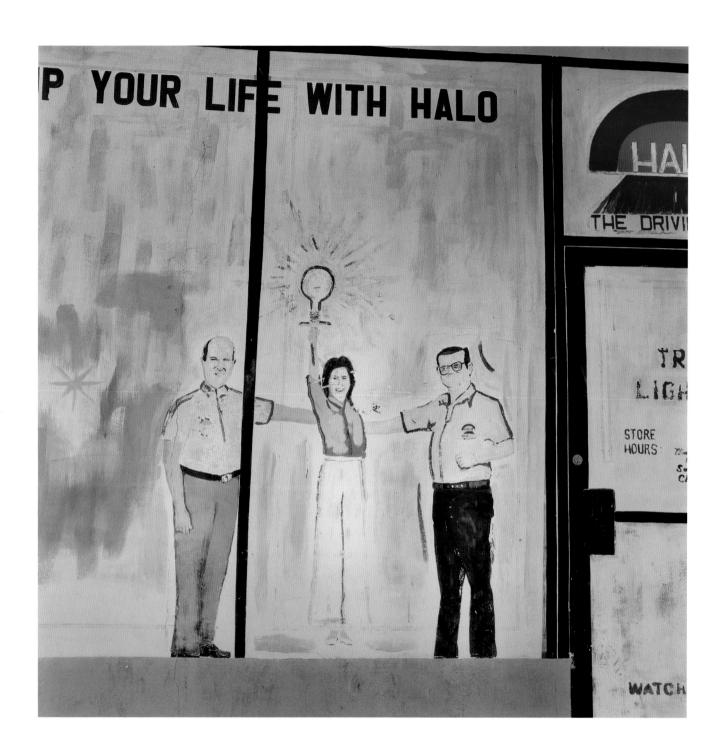

Miami, Florida, 2001

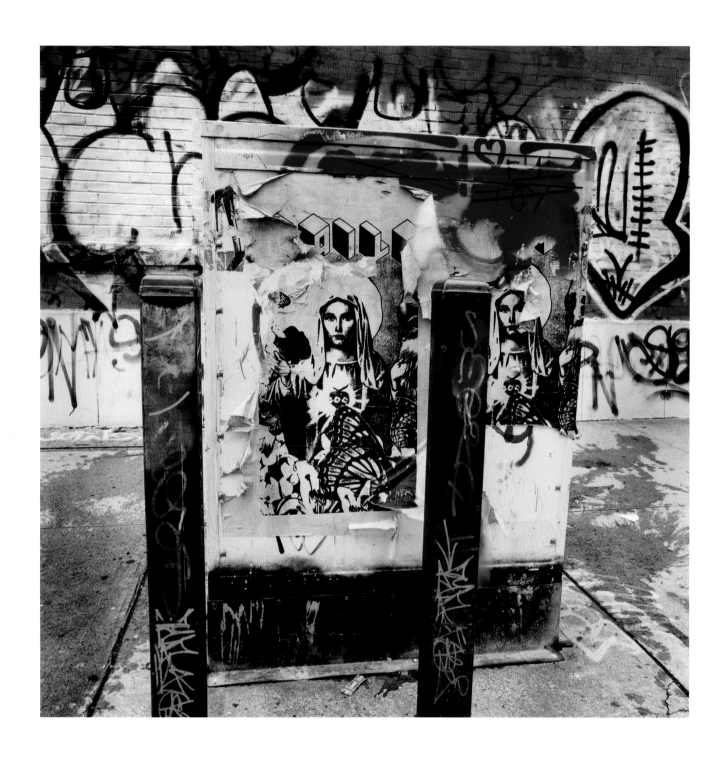

New York, New York, 2003

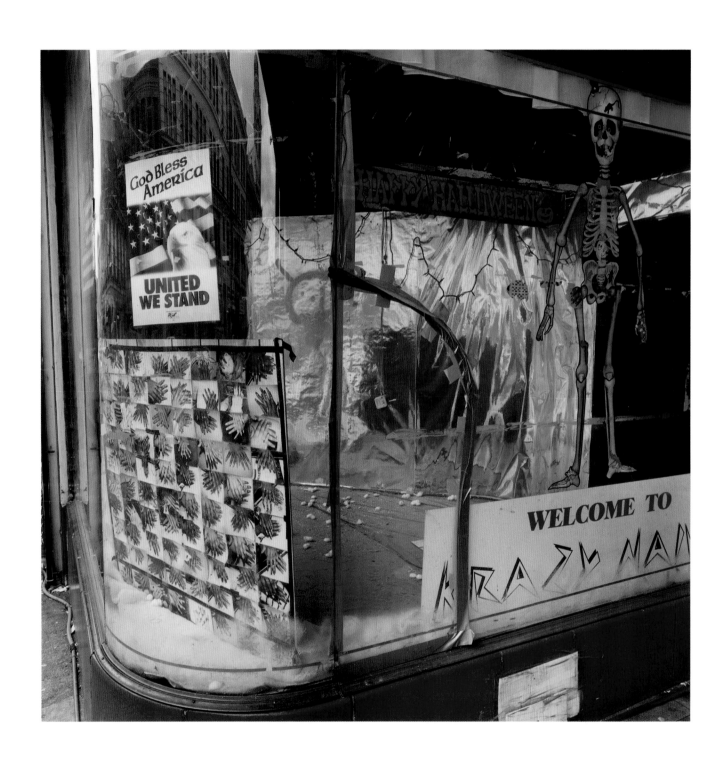

Paterson, Massachusetts, 2001

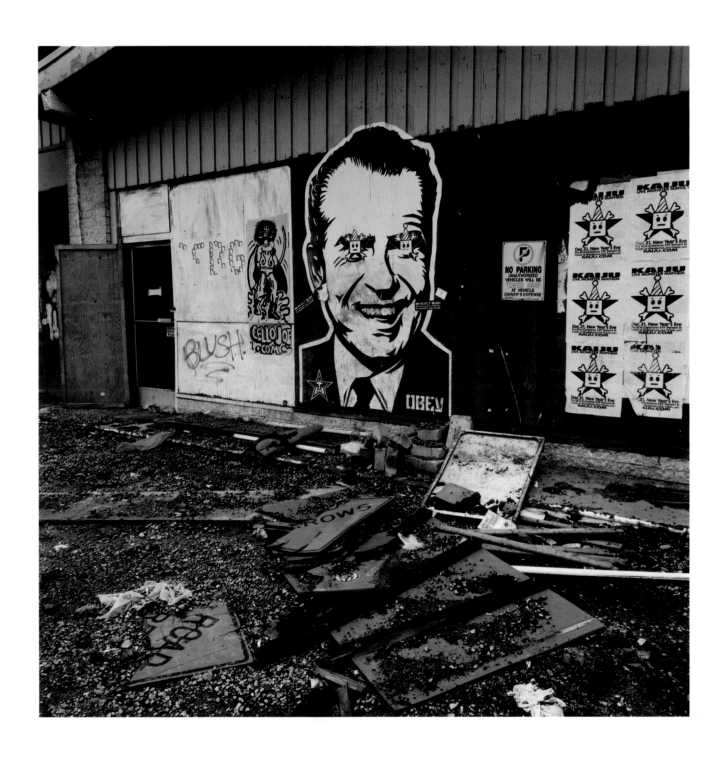

Cambridge, Massachusetts, 2003

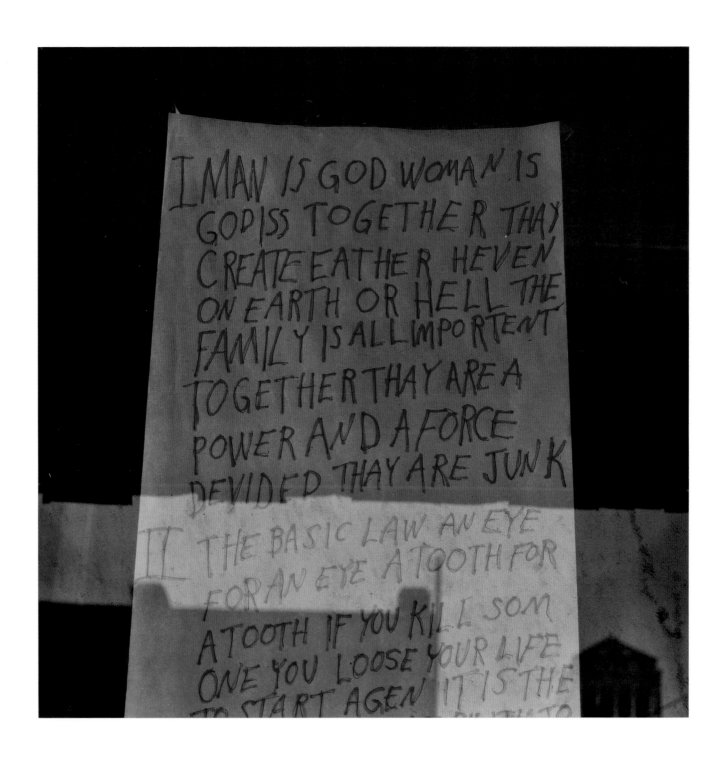

Salem, Ohio, 1993

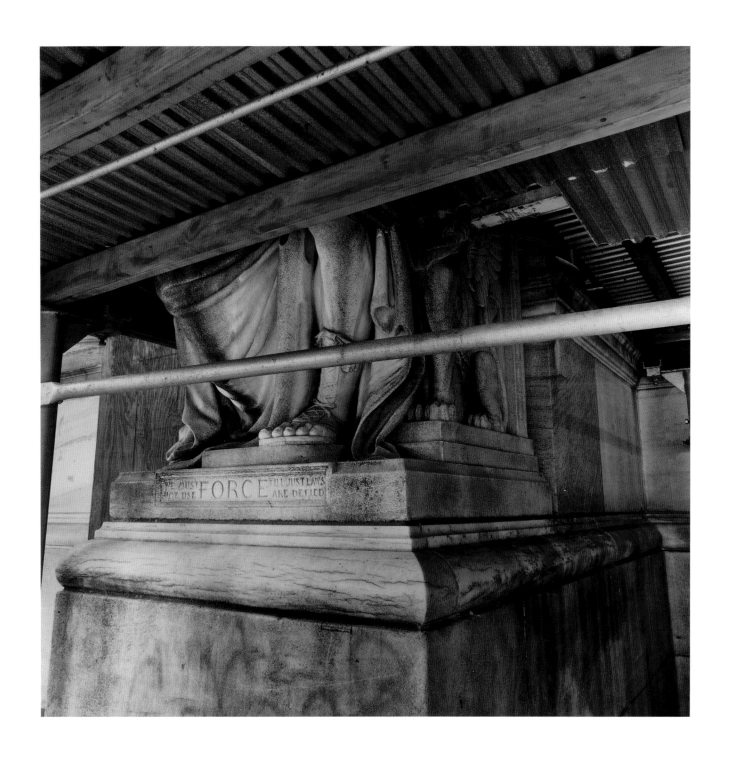

New York, New York, June 2001

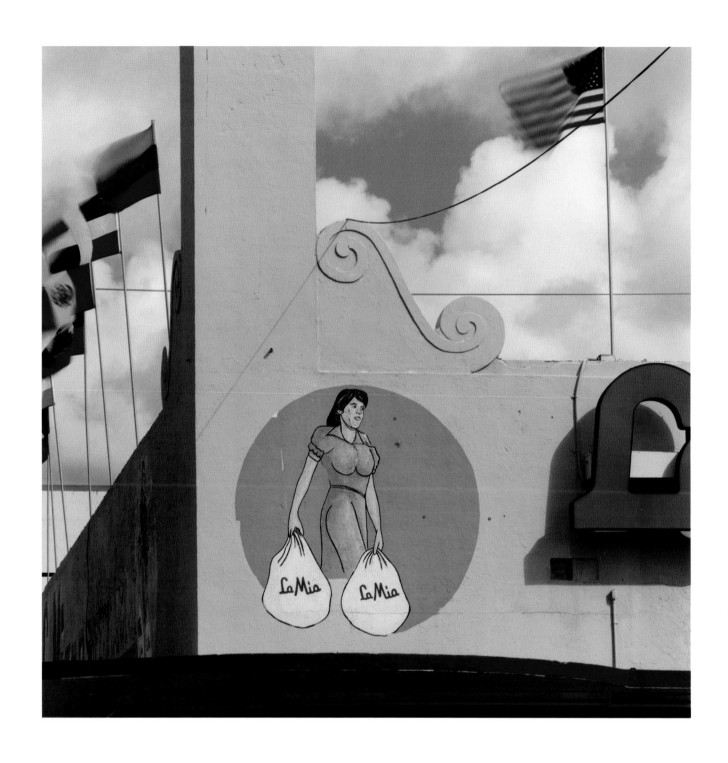

Miami, Florida, 2001

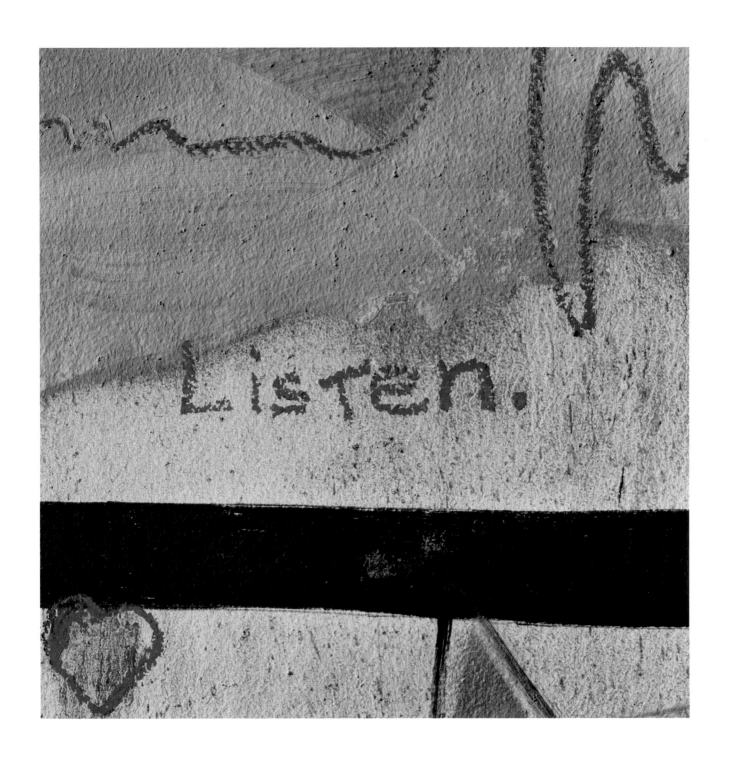

Tucson, Arizona, 2002

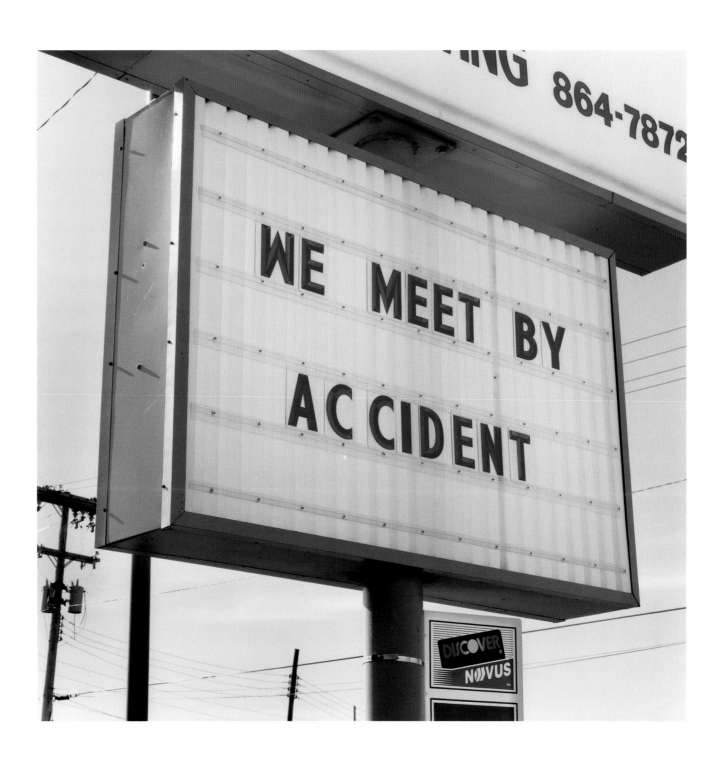

Springfield, Missouri, 1998

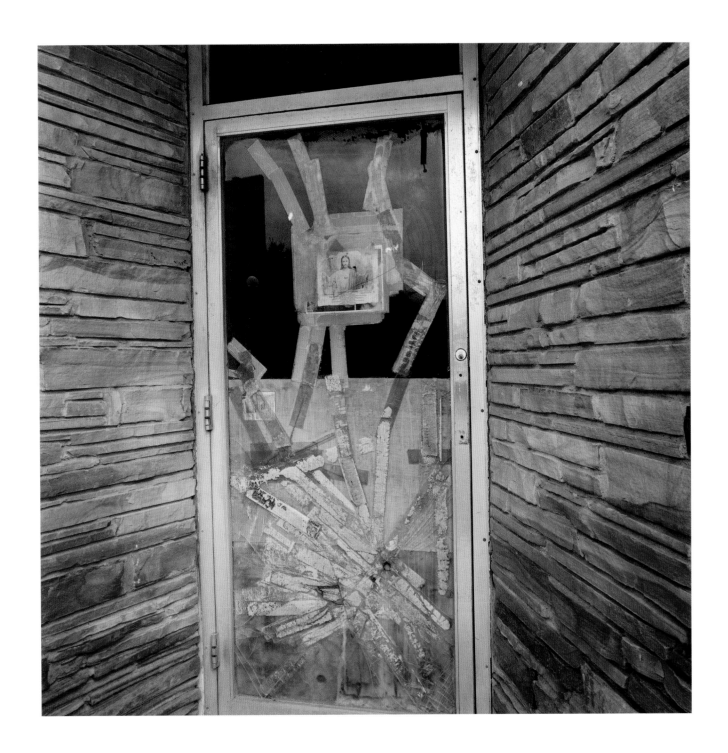

Corpus Christi, Texas, 1999

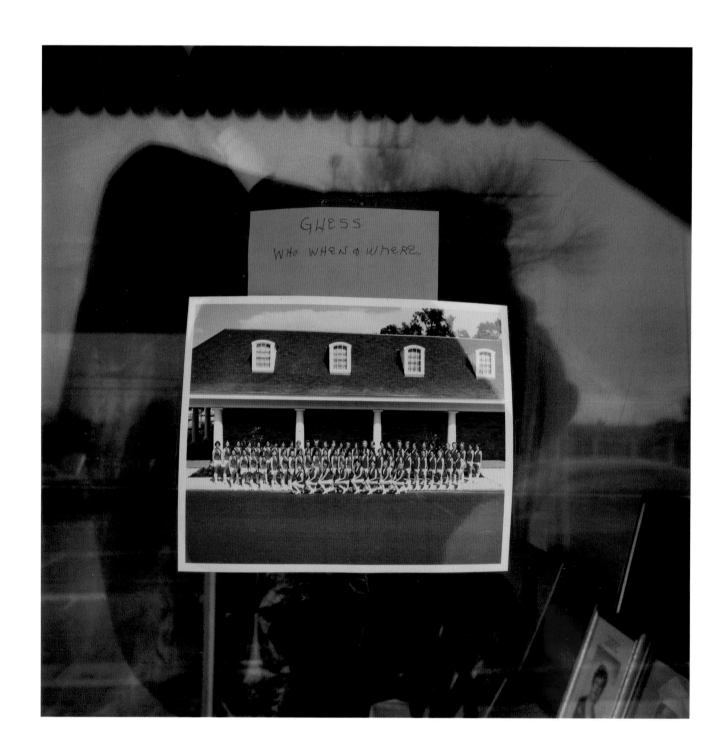

Minden, Louisiana, 1997

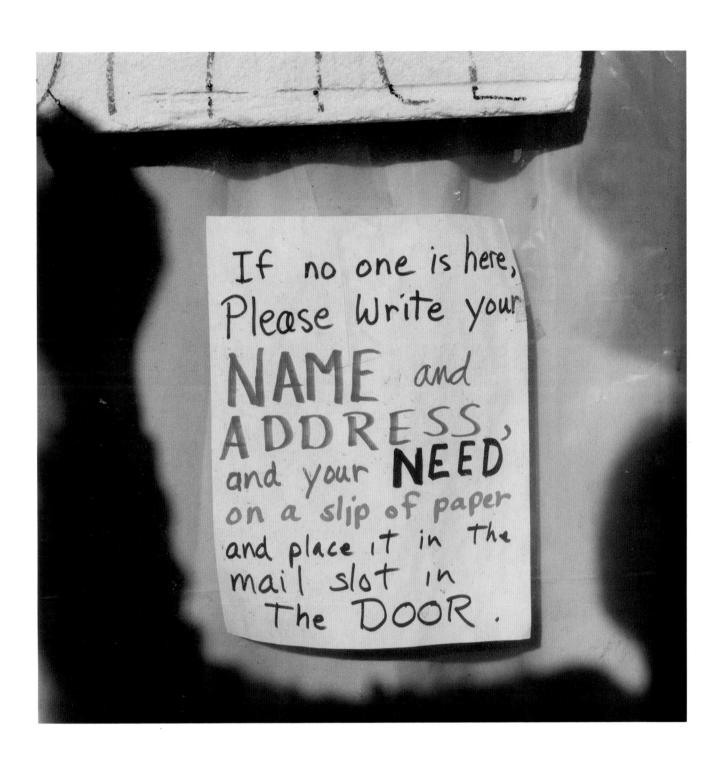

Independence, Missouri, 1997

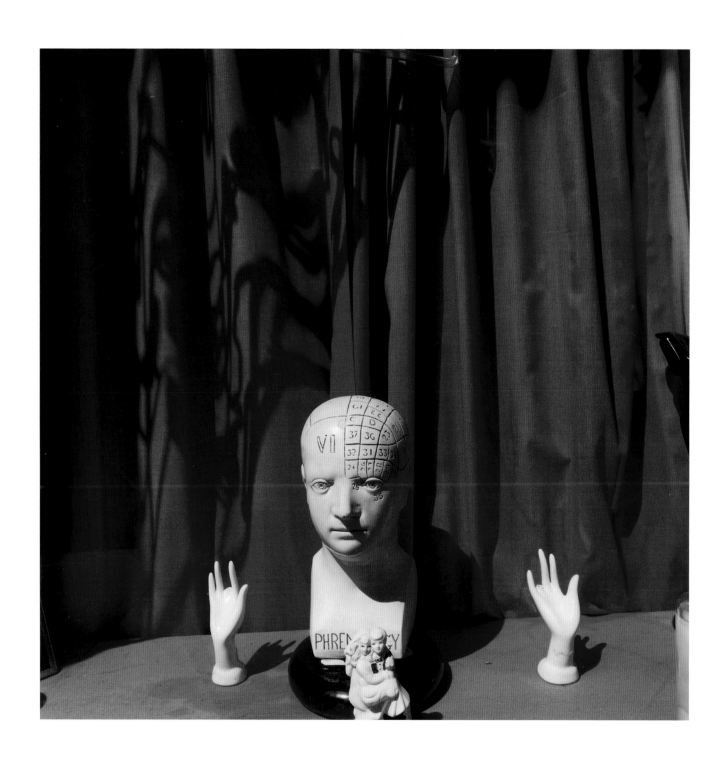

New York, New York, June 2001

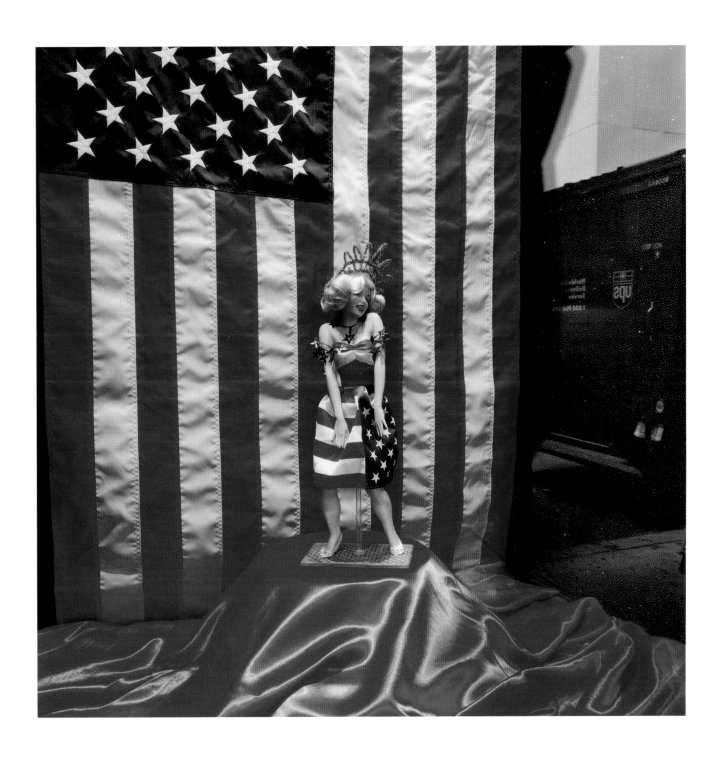

New York, New York, October 2001

Dedicated to Diane, Kari, and David

ACKNOWLEDGMENTS

The production of these photographs has been supported by Ryerson University research grants. Thank you to the faculty, staff, and students at Ryerson's School of Image Arts for creating a richly stimulating environment for the development of this book. I continue to be deeply indebted to Peter Higdon, David Harris, and Bob Burley for their ideas, encouragement, and friendship. Special thanks to my dealers Stephen Bulger, and Bernard Toale, and to my colleagues Vince Pietropaolo, Wayne Pittendreigh, and James McCrorie. To my excellent production team, Lindsay Page, Iain Cameron, and Robyn Cumming, I offer my respect and gratitude.

These photographs were made using a Hasselblad camera and various Kodak negative films and papers as they changed over the ten years of this project.

Shards of America
Phil Bergerson

Photographs © by Phil Bergerson

Salman Rushdie quote on page 5 is reprinted with permission of
the producers of TVOntario's "Imprint," September 2002

Design by Laura Lindgren
The text of this book is set in Gotham.

Manufactured by Mondadori Printing, Verona

Library of Congress Cataloging-in-Publication Data
Bergerson, Phil.
 Shards of America / Phil Bergerson ; introduction
by David Harris.— 1st ed.
 p. cm.
 ISBN 1-59372-010-6
 1. Signs and signboards—United States—Pictorial
works. 2. Show windows—United States—Pictorial
works. 3. United States—Social life and customs—
Pictorial works. I. Title.
GT3911.A2B47 2004
302.23—dc22 2004009603

THE QUANTUCK LANE PRESS
www.quantucklanepress.com
Distributed by W. W. Norton & Company, Inc.
500 Fifth Avenue, New York, NY 10110

W. W. Norton & Company Ltd.
Castle House 75/76 Wells Street, London WIT 3QT

1 2 3 4 5 6 7 8 9 0